A Landscape Photo o

Mo r

National Park

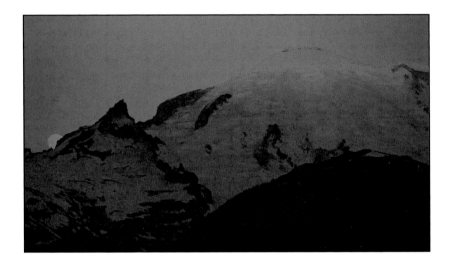

Anthony Jones

Right
Angles
Photography

For my wife and our two incredible daughters,
who support and encourage me
on every step along this journey.

Right Angles Photography
P.O. Box 473
Ravensdale, WA 98051
www.rightanglesphotography.com

Third edition

ISBN-13: 978-1-7321680-0-8

MAPS PRINTED IN THIS BOOK ARE FOR ORIENTATION ONLY AND SHOULD NOT BE USED FOR NAVIGATION.

Media Sources:

Satellite Imagery, pp. 4, 5, 102, 106, Google Earth, Copyright © 2018 by Google.

Park Maps, pp. 6-14, 28, National Park Service, public domain.

Image, p. 54, Copyright © 2015 by Rebecca Boatman.

All other images by the author.

Contents

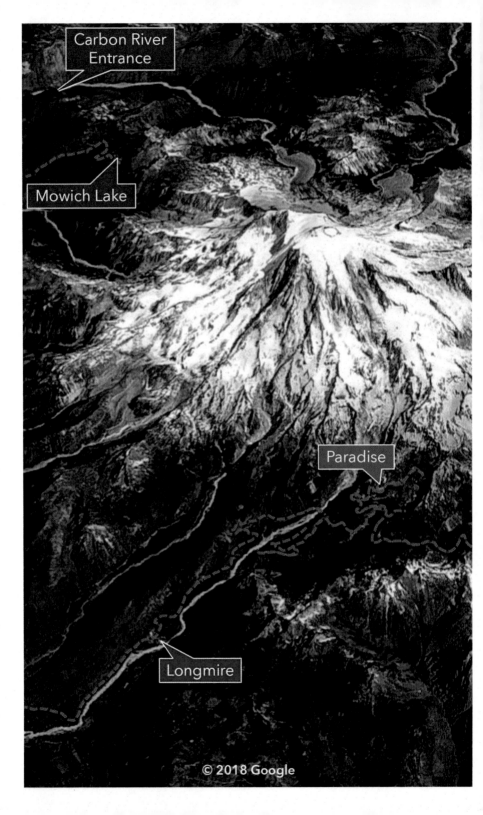

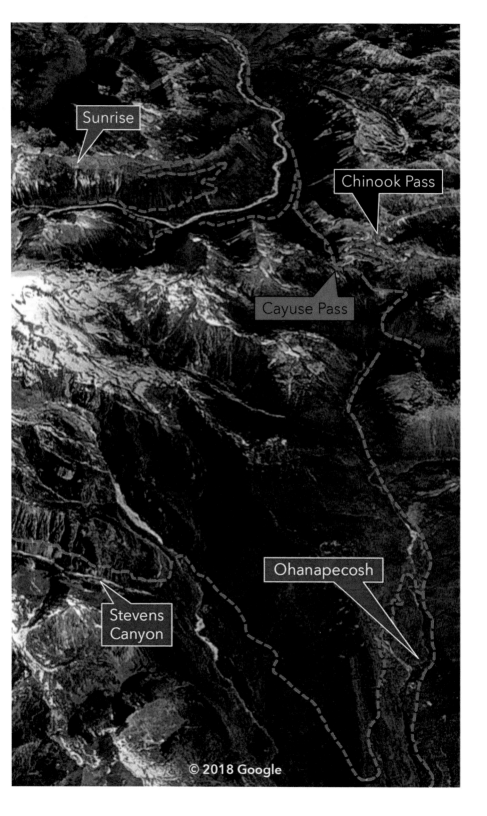

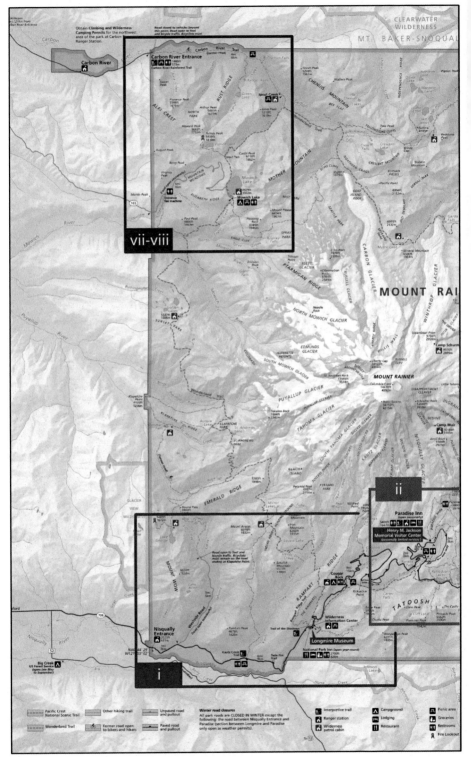

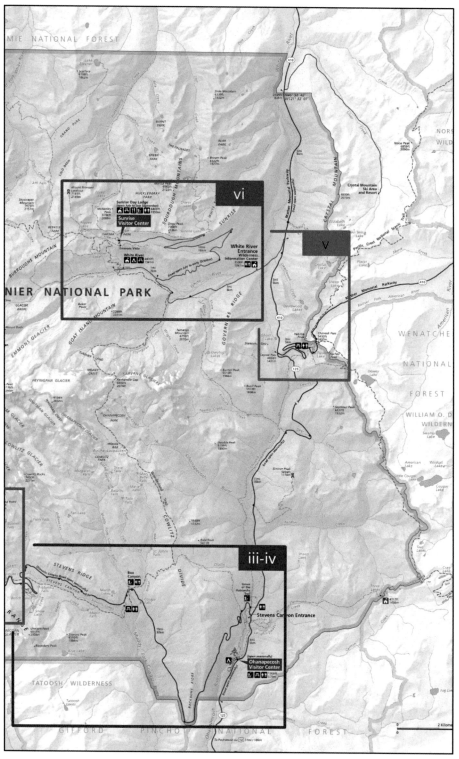

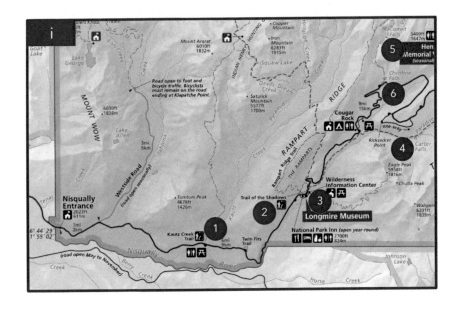

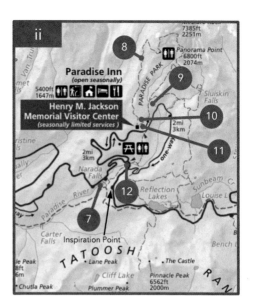

Map ii

Sites 7-12 this page.

Sites 13-15 next page.

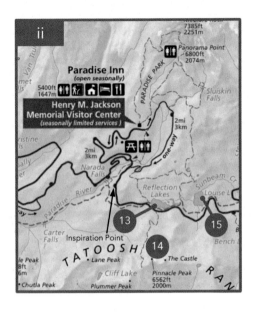

13. Reflection Lakes 68

The name says it all. This spot made the cover of the book!

14. Pinnacle Peak 70

Hike south to the rugged and rocky Tatoosh Range, and peer down upon Paradise with Mount Rainier towering above.

15. Louise Lake 72

No sign of Mount Rainier from the lake but still picturesque.

Glacial Alpenglow (from Reflection Lakes) 300mm f/8 1/40s ISO100

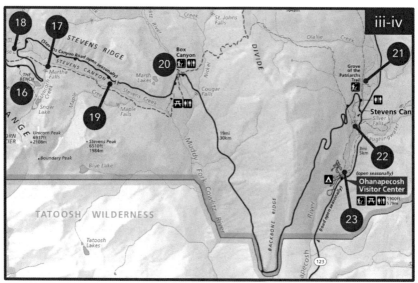

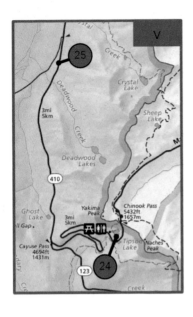

There are two mountain passes in this area – Cayuse Pass and Chinook Pass.

At Cayuse Pass, Highway 410 turns eastbound towards Yakima, climbing further via multiple switchbacks to Tipsoo Lake. Chinook Pass is just beyond Tipsoo Lake.

Highway 123 heads south towards Ohanapecosh.

Of interest, at Chinook Pass (the boundary of Mount Rainier National Park) is an overhead log sign and bridge, which serves as an over-highway walkway for the Pacific Crest Trail.

24. Tipsoo Lake 96

Another classic shot. More foreground opportunities than Reflection Lakes, though Mount Rainier is farther away.

25. White River Valley Viewpoints 98

A favorite and easy sunrise "pop shot" if entering the park for the day from the north. Time your arrival for first light.

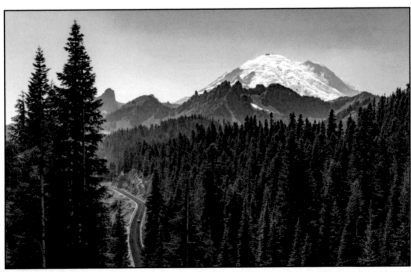

On the Road to Tipsoo Lake 50mm f/8 1/100s ISO100

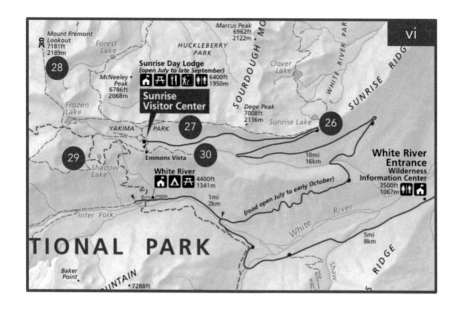

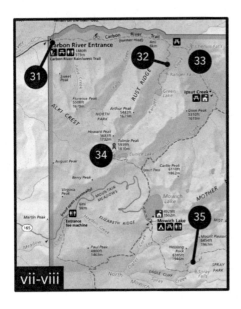

Introduction

Many of the now 63 national parks have an indistinguishable icon, a centerpiece to see and experience. And the hopeful photographer's desire – to capture its true essence via camera.

Mount Rainier National Park's icon is its namesake volcano, and at 14,410' rises high above neighboring valleys and ridges to be seen from many angles. Many compositions. What an opportunity!

But Mount Rainier (or "The Mountain," as locals call it) isn't all that this national park has to offer. There's so much more... Innumerous waterfalls, meadows bursting with wildflowers mid-summer, ancient forests, abundant wildlife. The list goes on and on.

But I suspect that you already know a lot of this. And so, this guide isn't designed to persuade you to visit Mount Rainier National Park. Odds are that you have already made the decision to go. *Yes!*

Then what *is* this book's purpose?

Its core intent is to guide you **-the photographer-** throughout the park, to minimize "blind exploration" for sites, and to maximize the number of praiseworthy images you take home.

This book is especially catered towards those who I like to call "weekend photographers." Those who may visit the park only for 2-5 days – and for some people what may be their *only* visit to this national park. As such, the sites presented herein are more likely to be roadside or very short hikes, in order to maximize experiences, when time is limited. (There are some longer treks on the list, for those who do have the time.)

My style is also to provide honest information. Not every site is a "must see" / ★★★★. So sometimes the news is great; sometimes not so great. The idea is that you're armed with enough information to create a daily itinerary that meets or exceeds your goals as a landscape photographer on travel. My own philosophy as a traveling photographer, is that I seek destinations where the reward matches or exceeds the effort to get there. This is one of the governing philosophies of this book.

How to Use this Book

I have divided the park, for the photographer's needs, into 8 areas. For quick reference, please see that each area's color is consistent throughout the book. (This is for quickly finding maps, sections, etc.)

While a lot of literature you will come across may speak to the park's history, geology, flora, fauna, and so on, this book will focus mostly entirely on elements useful to the photographer. I'm no historian, geologist, or botanist, and it would be wasteful to reproduce a lot of that information in here, as it would only add to the volume's heft. I sincerely hope that you have room for this book in your camera bag, and that you take it along with you every step of the way.

I've also omitted the most basic "general" photography lessons in here as well. There are many excellent resources on that topic. I will, however, cover some intermediate level topics that I think are relevant to making the most of your photography while at Mount Rainier National Park. The Tips & Techniques section is for exactly this.

So let's dissect the information presented for each of these hikes. The following is a sample, taken from Carter Falls (4):

Time	Best Good		Reward		
Budget	1.5-2.5 hr	Type	Out & Back	Effort	
RT Distance	~2.2 mi	Δ Elev.	~500 ft	Zoom	Norm, Tele

Time: The icons represent sunrise, early AM, late AM, midday, early PM, late PM, sunset, and nighttime. The red box(es) represent the best time(s) of day to be there. The blue box(es) represent good time(s). Ideally you are visiting during the "best" times, but itineraries do not always allow this, hence providing multiple options. The above site is best in the afternoon and also good early morning. *One major caveat here: Clouds can change everything (and normally for the better!), offering softer, more accommodating light during other times of the day. Make impromptu adjustments, accordingly.*

Reward: One to 4 "Wow's." Now honestly, if it warrants printing in the book, then it's got merit, right? So a 1-Wow here isn't like a 1-star motel. It's just relative! The above site scores a 3.

Budget: Your time is valuable, and this is how much time you might expect to spend at this site (including getting there, if it is a hike). For the sample site, plan for between 1.5-2.5 hours.

Type: This is the circuit that you will cover. "Roadside" involves some walking (but not hiking); you likely will work *near the side of the road.* "Meandering" means that there's not really a prescribed route, and so you should expect to explore the area via your own path. "Out & Back" is a route that you hike out one way, and then you turn around and hike back on the return. "Loop" begins and ends at the same place, though you mostly will not retrace your own steps. "Lollipop Loop" is an out & back with a loop at the far end.

Effort: This is the physical effort required while on the hike. Here, we are using the "Boots" scale. Zero Boots highlighted is typical for everyday walks, then 1-5 Boots reflect a hike's effort, similar to using the Easy-Moderate-Strenuous scale, but here with a 2-Boot representing Easy-Moderate and a 4-Boot representing Moderate-Strenuous. For the sample site, as you will read about on pages 46-48, the combination of noteworthy elevation gain over mileage warrants a rating of 3 Boots.

RT Distance: "RT" is Round Trip. This is the total hiking distance. Our sample site's round trip distance is approximately ("~") 2.2 miles. Also used at times is the symbol "<" to represent *less than.*

Δ Elev.: Change in Elevation. I need to be careful here. There are many ways to talk elevation and how it is recorded on a hike. For this book and this purpose, what is presented is simply the difference between your lowest elevation and your highest elevation. Some trails go up-and-down, and up-and-down, and so on. This value does not capture the summation of all those ascents and descents; it is merely the difference between the highest and the lowest points, while on the trail. For the sample site, the change in elevation is approximately ("~") 500 feet.

Zoom: I'm a firm believer in "less is more." Taking every lens on every hike can be backbreaking. And being weighed-down is no fun. So, in this box I'll suggest the key lens(es) you will want to take. Adding more is up to you. Using 35mm (full frame-equivalent) focal lengths, please consider "Wide" = Wide Angle (15-35mm), "Norm" = Normal (24-70mm), and "Tele" = Telephoto (70-200mm+).

Finally, each section will have photos of *hopefully* what you can expect to see and photograph – or do better than I could! Below these pictures are the camera settings that I used for the shot. Example:

Carter Falls

135mm f/16 1/4s ISO100

The Eight Park Areas

On the Mount Rainier National Park website, they divide the park into 5 areas – Longmire, Paradise, Ohanapecosh, Sunrise, and Carbon River / Mowich Lake (this pair as one). I've added two (Stevens Canyon & Cayuse Pass) and have separated Carbon River and Mowich Lake. My reasoning is that each is uniquely different, and I want you to think of them as such.

This book is arranged as if you're traveling counterclockwise around the park, entering at the Nisqually Entrance.

Let's take a look...

Longmire

If you're visiting the Longmire area, chances are that you entered the park through the Nisqually Entrance at the park's southwest corner, which means that you also drove in via Highway 706 through Ashford.

The Nisqually Entrance does have a very photogenic, timber park entrance sign. (I'm always a fan of having one of these in my photo album – it makes for a nice "intro" to your portfolio of park photos.) A parking lot is just west of it, so you can comfortably photograph it using a telephoto lens.

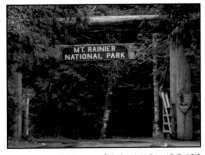

200mm f/2.8 1/13s ISO400

Enter the park, conduct your business at the pay station, and drive on. Wow – take note how the road and canopy are remarkably different now that you're inside the park. Narrow, twisting roads with minimal shoulder, and trees so close at times it feels like you can reach out and touch them. Slow down and enjoy this beautiful drive.

After 6 miles (about 15 minutes), you reach the Longmire Historic District. This is the oldest, modern era-settled area of the park, and the location of the original park headquarters.

What I most enjoy about Longmire (from a photographer's point of view) is its abundance of compositional *variety*, relative to the rest of Mount Rainier National Park. Between the Trail of Shadows and the

18

many, century-old rustic buildings, you have a lot of subject options beyond the traditional "broad landscape" and waterfall shots, typical at all other areas.

Included in the Longmire area are three waterfalls – Carter Falls, Comet Falls, and Christine Falls. Whereas your particular itinerary may or may not allow time for all, Christine Falls is a *must do*.

If this is your first time to visit Mount Rainier National Park, and you only have 2 days, my recommendation is to focus your visit on Longmire and Paradise, and add a few stops in Stevens Canyon. The variety across these south-end areas can't be beat on a very short trip. My point is – do not skip Longmire. It's awesome.

"The Mountain" from Ricksecker Point 70mm f/16 1/200s ISO400

Paradise

Paradise allows you to be literally "on the mountain." I mean, it's *really* in your face. There are some trails (albeit strenuous, especially if carrying a heavy photography bag) that will allow for elevation gain beyond the subalpine meadows of the Paradise area to alpine wilderness. And if you have the desire, gear, know-how, and permit, Paradise is the most popular starting point for mountaineers looking to summit its 14,410' peak.

But let's slow down a bit. I won't be guiding you on a photography outing to the summit of Mount Rainier. Though, for good measure, I did include the very popular and rewarding Skyline Trail hike, though

expect to spend 4-6 hours on it, with 1,700 ft elevation gain. It's "quintessential" Paradise, so if you're willing and interested, it's worth the effort.

For the waterfall connoisseurs, Paradise has several more to choose from... The most noteworthy three are presented in this book – Narada Falls, Myrtle Falls, and Ruby Falls. Like Christine Falls, listed in the Longmire section, Myrtle Falls is the *can't miss* for this area. Narada Falls' and Ruby Falls' "bonus feature" is their geographic orientation and the abundant mist they produce – therefore, both may be captured with a rainbow in view. (More on this in the Tips & Techniques section.)

While on the topic of exceptional sites, another *must do* is Reflection Lakes. The name says it all, and it made the cover of the book. If you have one morning to hustle early and welcome a rising sun, this is the place. It's breathtaking.

As suggested at the end of the Longmire section, the Paradise area is truly fantastic. It's my personal favorite, and I doubt that I'm alone here. While it takes a bit of an effort to get here (especially if compared to Carbon River, Mowich Lake, or Sunrise), it's worth it. **If this is your first time to visit Mount Rainier National Park, visit Paradise.** Adjust your schedule so that this may be achieved. You'll be glad that you did, and especially thrilled with the photos that you take back home.

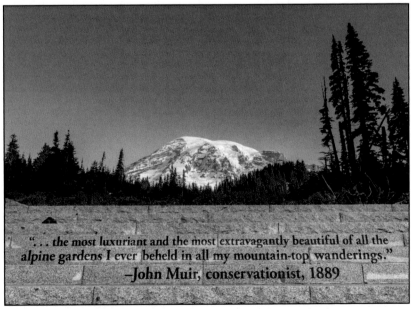

"... the most luxuriant and the most extravagantly beautiful of all the alpine gardens I ever beheld in all my mountain-top wanderings."
—John Muir, conservationist, 1889

Granite Steps to Paradise 28mm f/16 1/20s ISO400

Stevens Canyon

Unlike Longmire and Paradise, Stevens Canyon isn't really a singular destination, per se. I mean, you could tell someone that you visited Longmire, and they would have a pretty good idea of where you went. The same holds true for Paradise. Stevens Canyon – well, I suspect they would look at you funny if you said that you "visited" Stevens Canyon. However, there is one true way of doing just this, and that is hiking the Wonderland Trail. It follows Stevens Creek, which is at the bottom of this canyon.

There is one hike on the list that gets you closer there than any of the others – Martha Falls. It requires hiking on the Wonderland Trail to access the falls, and once you reach them, you're mighty close to Stevens Creek, as it runs *waaay* down below from the road up above. So, if you want to say you visited Stevens Canyon, in the literal sense, this hike is your means.

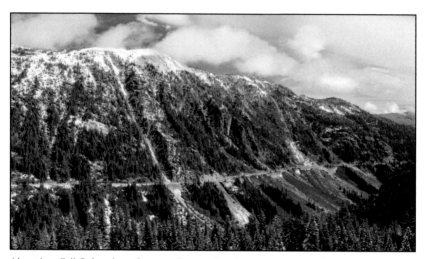

Abundant Fall Color along Stevens Canyon Road 24mm f/8 1/125s ISO100

Otherwise, Stevens Canyon is simply a broader area, used here to capture the essence of a larger boundary within the park. (For this book's sake!) Though I will say this – it is quite purposeful to think of this east-west corridor for one thing in particular... **Fall color.** Oh wow, does this canyon light up with color! Its season may be surprisingly short though, because it doesn't take long for the snow to come fast and deep, and at some point the National Park Service ceases to plow for the season, and electing to close-off the road entirely until late in the following spring. So if you're nearby, have time, and there are fall color reports, come quickly. It may snow tomorrow.

Ohanapecosh

I've had a few good laughs at *myself* while researching for this book. One of those laughs came as I drove through the Ohanapecosh campground for the first time... I'd made the turn so many times off of or onto Highway 123 at the Stevens Canyon Entrance, but not ever in the direction of Ohanapecosh. I thought to myself, "it mustn't be that interesting. Why bother?" I believe that life is about learning lessons, and that was a lesson that I learned that day. And I got a good laugh out of it to boot.

Heading towards Ohanapecosh is downhill, if you're going south on Highway 123. That change in elevation brings with it a very noticeable change in vegetation. I couldn't believe how green it was quickly becoming!

The lushness of this place, plus (as I'll mention again later) what's perhaps the best campground in the entire park... Well, it's simply worth visiting. And sometime soon. Don't do what I did and wait for years to check it out. Go sooner. You'll be glad you did.

Ohanapecosh also includes Grove of the Patriarchs — an ancient cluster of enormous, old growth trees. Visiting these trees is another *must do*. While not as tall as Coast Redwoods and not as round as Sequoias, they are massive. And testament to how big most all of these evergreen trees are capable of getting in these Cascade forests, if they were only allowed. By grace or good fortune, the trees on this small river island were allowed to be, and today we can experience their might, very intimately.

Bunchberry Dogwood 28mm f/2.8 1/30s ISO200

Cayuse Pass

Cayuse Pass is an unusually large, triangular-shaped intersection of Highways 410 and 123. Study your map and signage carefully on your approach – unless your goal is to visit Tipsoo Lake or any of its surrounding areas, you ultimately will be exiting the park if you head further east on Highway 410, up and over the next mountain pass (Chinook Pass) in the direction of Yakima, WA.

What I like most about the Cayuse Pass area is its very easy sunrise potential. If you're coming into the park for the day (or for an extended stay), and you find yourself entering via the Mather Memorial Parkway (Highway 410 from the north), it is extremely convenient to "time" your approach to this area for first light. Either stop and wait at the roadside White River Valley Viewpoint for a very easy composition, while you may still be sitting in your car enjoying coffee and breakfast, or opt for the short detour and easy-to-access east side of Tipsoo Lake for a stop. Finish your work, likely having checked off the list some easy, beautiful sunrise pictures, and then continue to elsewhere in the park for the remainder of your day.

Sunrise

Sunrise should be saved for your 3rd day visiting Mount Rainier National Park.

I'm happy with that statement, though I bet that some of you reading this book will have a pretty good "what the heck?" look on your face. I'll explain...

The area is popular, and admittedly for good reasons – it's close for people making day trips from the Seattle area, you're at a relatively mesmerizing elevation, and Mount Rainier is sooo close. But, as I see it, it has one major issue... No matter which trail you take, the view (of Mount Rainier) feels mostly unchanged. So, if we compare it to its next-closest sibling, Paradise, it just doesn't offer a lot of variety to explore – especially for the visiting photographer.

But hold on, there are some noteworthy positives...

Sunrise does possess one advantage matched nowhere else in the park – the very best picnic area for lunch! I've made mention of this on some of the area hikes... Plan a hike, by yourself or with friends or family, pack a lunch suitable for picnic table dining, and head to Sunrise for the day. If it's summer, do bring sunscreen though. Many of the tables are not in the shade. (The shaded tables seem to be constantly occupied.) Hike before, or hike after. This combination of hiking and outdoor dining is hard to beat.

Wildflowers! Oh wow, can they be in abundance at Sunrise. The Yakima Meadow (the one visible from the parking lot) can be flush with color, and if you're willing to tackle some distance and elevation on a trail, the hike to Shadow Lake and back nets enough elevation and microclimate change that you're even more likely to dip in and out of wildflower blooms. But this requires some timing and agility with your schedule planning, as the wildflowers seemingly come at once and don't last long.

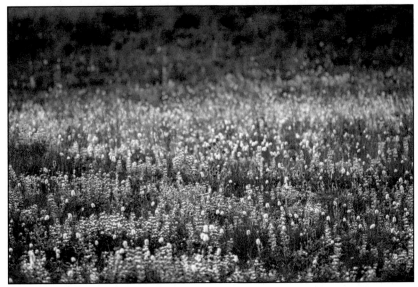

Last Day's Light on Sunrise Wildflowers 300mm f/5.6 1/250s ISO400

If you are interested in astrophotography, Sunrise is the most easily-accessible *northerly* viewpoint of Mount Rainier. This orientation is key for photographing the Milky Way. Utilize a "Planisphere" (a portable star-finder), or use any number of popular online tools or mobile applications to forecast its orientation in the sky for a given night and time. Beware of abundant moonlight as well as cloudy skies. ...Some real agility in planning is obviously required here. Luck too. See page 82 for the result with an ultrawide angle lens on the southeast section of the loop along Sourdough Ridge, near a National Park Service self-guided tour post in the ground marked "4."

Lastly, to be fair and potentially debunk my earlier remark on the "issue" with Sunrise, the hike to the Mount Fremont Lookout is worthwhile and *truly unique*. At the fire lookout (tower) a 360° view is available with an alternate vista of Mount Rainier. *A different perspective*. Plan for a morning hike and a lunch at the top – it's sensational. Be on the lookout in the terrain below the trail for mountain goats.

Carbon River

Carbon River's fame is its inland, temperate rain forest. It's small, and it doesn't have a formal name, but if you're looking for an easy-to-access area of Mount Rainier National Park that affords some interesting (and often wet!) compositions, this little gem is worth seeing.

Visiting Carbon River, for a lot of people, is as much about the drive as it is the destination. Not only is it the closest entrance to the greater Seattle area of all the park sites, but you make your way through some quaint, little towns on the way there. If there were a book of "Family Sunday Drives," this would make the Top 10. Enjoy this peaceful drive, a short walk through a rain forest, and perhaps a riverside picnic lunch before hiking some more or heading out.

The drive once offered more, until a 2006 flood damaged enough of the gravel road within the park (beyond the now parking lot) that it was closed. It remains closed, and in all likelihood will not ever reopen to vehicular traffic. What this means for visitors, is that the hikes beyond the parking lot and rain forest loop require additional hiking or biking to reach any of the sites' trailheads. Did you catch that? "Biking." This has been my preference, and I know that it doesn't suit out-of-town visitors well, but if you have the means to take a bicycle with you, it really shortens the overall duration and effort of these further-out hikes, as well as offering a fun and unique experience within the park. I have provided some additional detail on this later in the book.

Cycling the Carbon River Road 35mm f/5.6 1/160s ISO400

Mowich Lake

Everything about Mowich Lake is remarkable, though not for any sort of an "easy" visit. Its hikes are longer (yet very rewarding), and driving to the lake area is a very long and bumpy adventure.

Eunice Lake 85mm f/5.6 1/640s ISO200

The hikes first... The two popular excursions are outlined – one in the direction of Eunice Lake and Tolmie Peak, and the other in the direction of Spray Falls and Spray Park. Each a day hike, and each providing uniquely-different sights. An option to consider, if you enjoy camping, is to drive in and hike Eunice Lake and Tolmie Peak one day, camp at the walk-in campground, and wake the next morning for a visit to Spray Falls and Spray Park. I have done this before, and thoroughly enjoyed it. The Mount Rainier National Park website will have more information on the campground details. It is first come, first served, so summer weekends could be busy. Weekday camping may net more favorable results.

Now for a brief discussion on the drive to Mowich Lake. I want you to be prepared... The road, from the fork to Carbon River, begins asphalt, but changes to gravel quickly. It is closed in the winter due to snowfall, and is unplowed until it is reopened in the spring. (Check road closures on the Mount Rainier National Park website.) From my experience, once it has been reopened in the spring, the road is at its best – meaning, at its most smooth. Then, throughout the summer months, it gets a very washboard-like surface, and driving – no matter if you drive slowly or more briskly – becomes **incredibly bumpy**. *Fifteen miles of bumps and jiggles.* My truck's brake pedal was pulsating so much one day over these bumps that I had to support its backside with my left foot so that the brakes wouldn't engage! True story. ...I am not trying to discourage your visit. Just take your time, and be patient with the conditions. The prize at the end of the road is magnificent.

Tips & Techniques

As briefly mentioned in the "How to Use this Book" section, I want to share with you what I think are some of the more unique pieces of advice for your trip to Mount Rainier National Park. Some of this information is park-specific (logistics and planning, mostly), while other information is photography-related (i.e. techno-talk).

Let's get straight to it...

Additional Resources
Please do not skip this!

My goal, in writing this book, is to minimize the resources that you must seek-out, purchase or print, and ultimately rely on in order to enjoy *photography* at Mount Rainier National Park. So, along with the purchase of this book you need access to three additional resources:

1. The Mount Rainier National Park Website (www.nps.gov/mora/index.htm),

2. A printed copy of the National Park Service map of Mount Rainier National Park, and

3. Printed copies of the main park areas' trails (which are in more detail than the main park map).

The Website...

I'm not going to guide you through the whole website – that would be silly. Though, it is in your best interest to make some time and explore it completely, or very close to. Also, a disclaimer – some of these subcategories listed here may change names over time, as the website evolves, so if you cannot find what you're looking for based on my guidance here, try finding it outside the website with your favorite search engine. Just be sure that when you follow the results, you're staying within the www.nps.gov domain. It is the most reliable.

Alerts

On the top banner there is a link to park alerts. This could be abnormal weather or road conditions, or any upcoming or emergency activities that visitors need to be aware of. Check this ahead of your trip, and as connectivity allows, check it regularly during your trip.

Weather

A direct link is available on the homepage. Mountain weather conditions can change very rapidly. Again, as connectivity allows, check this regularly during your trip.

Maps

Again on the top banner, follow the maps link for an abundance of great information. Your first mission is to find and download the PDF of the park map that you will be provided once you arrive at a park entrance pay station. These maps are worth their weight in gold. I advise to print in color your downloaded copy on the largest paper possible. The copy you will receive at the park, unfolded, is approximately 24 x 16 inches. This is the same map used on pages 6-14 of this book, and the same map that I listed as Item 2 above for you to carry during your visit.

You're not done printing yet. The same, more detailed trail maps (Item 3 above) that are available on letter-size paper at the Visitor Centers are also online. These PDF's are found under the following titles: Longmire Trails, Paradise Trails, Ohanapecosh Trails, Sunrise Trails, and Carbon & Mowich Trails.

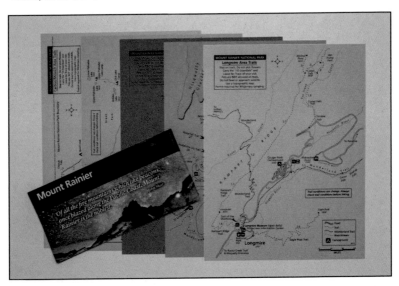

Plan Your Visit ▶ Things to Do ▶ Discover Wildflowers

Accessing this tucked-away page is quickest using the site's top banner. If you're visiting during wildflower season (normally mid-July to early August), familiarizing yourself with this page and its subsequent links will pay huge dividends to your success "finding"

wildflowers in bloom. Any given week, it will help you assess exactly where in the park to visit. (It is typically updated twice per week.)

Driving Information

There are no fuel stations inside Mount Rainier National Park. Some national parks have fuel; some do not. This one doesn't. Plan accordingly.

When studying these maps, the driving distances do not seem that long, and therefore may surprise you. Case in point — the distance between the White River Entrance and Sunrise appears short but is 13 miles and takes between 30-45 minutes! Here are some typical distances and driving times:

Longmire to Paradise	12 mi	25 min
Paradise to Ohanapecosh	23 mi	45 min
Ohanapecosh to White River Entrance	18 mi	30 min
White River Entrance to Sunrise	13 mi	45 min
White River Entrance to Carbon River Entrance via city of Enumclaw	61 mi	2 hr
Longmire to Carbon River Entrance via city of Eatonville	80 mi	2.5 hr
Longmire to Mowich Lake via city of Eatonville	89 mi	3 hr
Carbon River Entrance to Mowich Lake	24 mi	1.5 hr

A little-known fact, the park's Westside Road was originally intended to provide access between Nisqually and the Mowich Lake & Carbon River areas. It's too bad this project was cancelled.

Seasons

In order to make the most out of what Mount Rainier National Park offers photographers, it is only practical to plan on visiting in the summer and the first ~3 weeks of fall. The snow comes early (figure on the 2nd or 3rd week of October), and it stays until road plows finish clearing it in late spring or early summer.

The Longmire area and the Carbon River Entrance remain open year-round, and the National Park Service works to keep the road open from Longmire to Paradise (weekends only) during the snowy months. Thus, my recommendation is this – if you plan to visit anytime except for the summer, do check the park website for operating hours and closures. Spring seems to come late and last briefly, and fall is short as well.

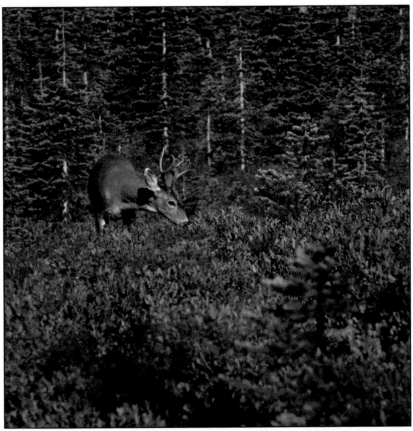

Young Buck Grazing in Late September 200mm f/11 1/500s ISO400

As with many national parks, the real influx of visitors is in the summer. Perhaps this is when you will visit too. The very best time to visit in the summer is when the wildflowers are blooming. I have read that visitors come from all over the world to see them. It's believable. They're truly magnificent. As mentioned earlier, check online for blooming status. **The most popular and promising places for wildflowers are Paradise Park, The Bench, Tipsoo Lake, Sunrise, and Spray Park.** There are others, but these listed are specifically outlined in this book.

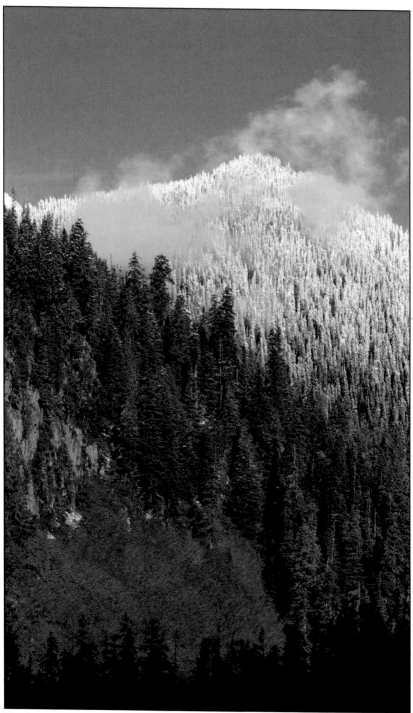

First Snow and Rich Color along Highway 123 50mm f/8 1/500s ISO100

Fall is magnificent, and like many other travel destinations, crowds are much smaller. But again here we are counting on planning with some luck involved for good timing. If I were to wager a bet, I would try for the first week in October. (And I sure do hope that if you take this advice that it works out splendidly!) Mid- to late October has plenty of color too, but at anytime snow can more typically interrupt the best of plans. **The best places for fall color are Longmire, Paradise Park, Stevens Canyon, Grove of the Patriarchs, and along Highway 123 between Ohanapecosh and Cayuse Pass.**

Fall has a real bonus feature in this area, and it's actually just outside the national park boundary. East on Highway 410, past Chinook Pass and into the Wenatchee National Forest is a very rare tree species – the Western Larch. Western Larch is a conifer, but it is not an evergreen. Their needles turn a beautiful yellow in the fall! Many people have never heard of this phenomenon, much less seen it.

To find these Western Larch, continue east on Highway 410. Just past Tipsoo Lake an over-the-road, large timber sign welcomes you to the Wenatchee National Forest. You crest Chinook Pass. Check your odometer... And now be on the lookout! You will know it when you see them. Lodgepole Campground is approximately 7.5 miles from Chinook Pass, and a good area to explore. It's also a good place to turn around (if you did capture photos). If you're feeling adventurous, I have found that the Western Larch go as far east as about 15 miles from Chinook Pass. But beyond that point, there's not many to see.

Hills of Western Larch 300mm f/8 1/50s ISO100

Moss and Western Larch

250mm f/8 1/60s ISO200

Filters

Polarizing Filter

Do not leave home without your polarizing filter. There are lengthy articles on linear polarizing filters vs. circular polarizing filters – the topic is in my opinion too scientific for this book... If in doubt, use a circular polarizing filter. Most modern cameras will not meter correctly with a linear polarizer. (If you are still curious on this topic, seek further wisdom online.)

Aside from a functioning camera, a polarizing filter is the most important tool in your camera bag. Most are round and are threaded to screw onto your camera lens. Though, not all cameras and camera lenses have threads to accept accessory filters. Adapters are available for nearly every configuration. Once again, check online for availability for such adapters, if necessary.

A circular polarizer has a rotating front element, that when turned (and while you're looking through it – either by itself or through the camera) reduces glare and reflection of light. It also tends to enrich colors. And while colors' "pop" may be simulated using saturation and hue adjustments during post-processing, I have yet to find a computer program to date that can easily simulate a polarizer's effect on water. This is where it really shines. On a lake scene, look to the polarizing filter to reduce glare, to see "into" the water, and sometimes enhance the reflections on the water's surface that you do want.

One caveat to polarizing filters... They really only work when the light source (the sun) is at a substantial angle, relative to the lens. At sunrise and sunset, you will not experience its effects. During very early morning and late afternoon, its effect will be minimal. Mid-morning through mid-afternoon, they work best. No need to memorize all this! Experiment, and enjoy learning its behavior.

Neutral Density Filter

A neutral density (ND) filter is like a pair of sunglasses for your lens. Its purpose is to filter light, so that you can apply longer shutter speeds. This is the "density" part of its name. The "neutral" piece implies that its use won't impact the color tone of your photograph, but in reality they all do somewhat. And typically, the darker they are, the more un-neutral they become.

Like circular polarizers, the most typical format are those that screw onto the front of the lens. They come in an abundance of varieties, but if you are just starting out, my recommendation is to select a 4-stop (1.2) neutral density filter.

Why use a ND filter? For the landscape photographer the most common application is for use with waterfalls. If your desire is to create that silky-looking flow of water, you need to really slow your shutter speed down. Take a look at the shutter speeds used on waterfalls throughout this book. For the look I'm describing, you generally need to be 0.2 second or longer. My rule of thumb is 0.5 to 2 seconds. Any more isn't doing as much for the look of the water, but perhaps the rest of your scene benefits otherwise. While on the topic of waterfalls, I intentionally placed one photo of a waterfall with its vigorous flow of water captured – close to how it looks in real life. See page 91 for Silver Falls, which was taken at 1/100 second.

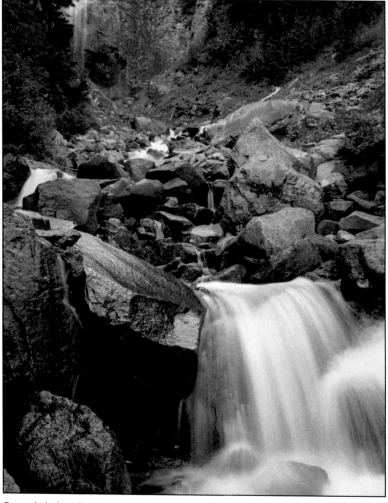

Cascade below Spray Falls 35mm f/16 0.6s ISO100

Rainbows

There is a lengthy way to explain this and a concise way. Here is the latter... We can *plan* for rainbows in the mist of waterfalls. The concept is 3-part and works for I'd say 95 out of 100 scenarios:

1. The sun will be behind you. It may be behind and above you, as in "over your shoulder," or it could be directly behind you. Or behind you and off to one side. Some variation exists here, but to say it another way, you will not *see* the sun with your eyes. Otherwise you would have eyes in the back of your head!

2. The fun part – the shadow of your head (or where the shadow of your head would be) marks the center of the rainbow's "circle" (if it were a compete circle). Yes, think of it not as an arc but a circle, as if it completed its loop below the ground. Your head's shadow is at the center. If anyone asks, this is called the "antisolar point."

3. Now for its location in the mist... This is based on the *sun's* position and *your* position. (This is the interesting *and* challenging part.) We blend the elements of Items 1 and 2 above for this final "rule."

 For a "primary" rainbow, where red is on top, the viewing angle ranges between 40° for violet and 42° for red. To keep things simple let's consider it at approximately 45°, which is half of a right angle (90°).

 For a "secondary" rainbow, where violet is on top, the angles vary between 52-54°, so again for all intents and purposes, out in the field "half" of a right angle is sufficient here as well.

 Translation: as you move, the rainbow you are seeing moves! This is great news, because it puts you in the driver's seat a bit on where it is (compositionally, as a photographer) and maybe also how vibrant it is.

Check out the illustration on the adjacent page. (You will need to rotate the book sideways.) Try to envision a few things: When the sun rises or falls, what will be the impact if the person stands still? If the person moves, what will be the impact? Movement matters here – whether it's the sun or the person. The rainbow will *change* accordingly.

Rainbows in the sky – well, they're not as predictable. Unlike those in waterfalls, we cannot really "plan" for them. We can, however, react to them and make swift decisions on how we place ourselves to potentially improve the result.

Use your circular polarizer when photographing a rainbow. It can boost the colors, but be careful – you can apply so much polarization that the colors disappear. So experiment. There is a bit of a sweet spot.

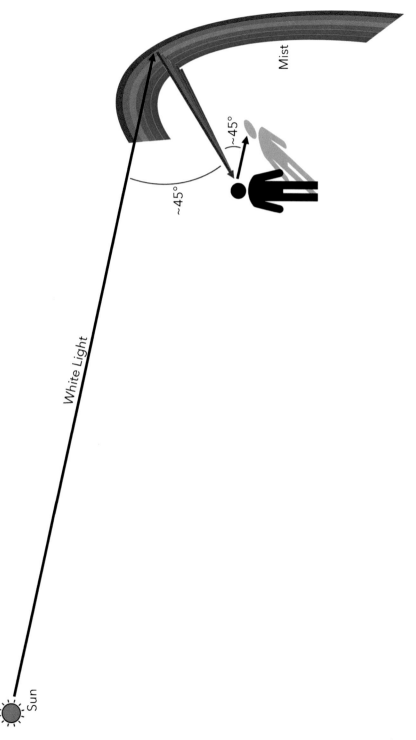

Mist

~45°

~45°

White Light

Sun

Window Seat View

Whether you are flying into Seattle-Tacoma International Airport in order to visit Mount Rainier National Park, or you find yourself on an airplane flying into or out of this airport for another trip, if you can obtain a window seat you might have one of the best views yet.

Many flight paths skirt the perimeter of Mount Rainier very closely and at a low enough altitude for a really amazing view.

And so here is a great reason to have a camera with you and handy while on the airplane.

Which side of the airplane to sit on is the question. Flight Aware is an online service (website) that provides typical route information for flights. You can plug in your airline and flight or departure and arrival cities to assess where through Washington state your airplane is expected to go. Mount Rainier is southeast of "Sea-Tac."

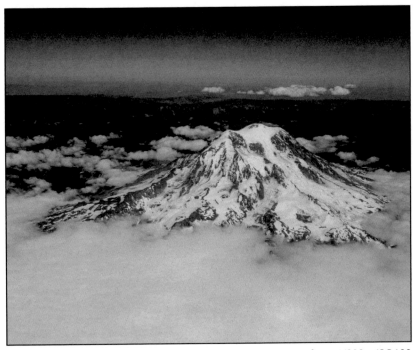

Mount Rainier 35mm f/11 1/800s ISO100

I always prefer a photo album to be organized in a sequence that tells a story, and this shot makes for an excellent "arrival" or "departure" representation of your visit to the park, for those of you flying-in for time here.

Longmire

Nisqually NP Entrance to Ricksecker Point

"Iron Mike" along the Trail of the Shadows

16mm f/22 25s ISO100

Time	Best Good			Reward	
Budget	15 min	Type	Out & Back	Effort	
RT Distance	~500 ft	Δ Elev.	~10 ft	Zoom	Telephoto

If you're entering the park via the Nisqually Entrance (the southwest entrance just east of Ashford), and you have 15 minutes to spare, I highly recommend pulling off into the large parking area at the Kautz Creek Trailhead for an easy and enjoyable boardwalk to a simple but serene viewpoint of Mount Rainier. I mean, this is what you came here to see – right? Stop and have a quick look!

This parking area was revitalized recently, and I suspect that's why this spot has something not-too-often seen elsewhere in the park – a clever, brown sign with a camera on it denoting the photographic potential. (So if you're traveling with kids or even curious adults, make it a scavenger hunt to locate others. There aren't many!)

Remember, this is a fun and quick shot. Mount your telephoto lens onto your camera, and leave the rest behind at the car. Follow the boardwalk to the gravel viewing area with benches, explore the small area on foot, and select your favorite composition.

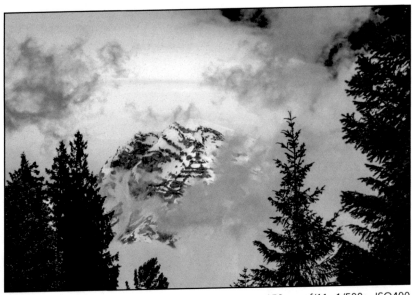

Kautz Creek Viewpoint 150mm f/11 1/500s ISO400

Time	Best Good								Reward				
Budget	45-60 min			Type		Loop			Effort				
RT Distance	~0.7 mi			Δ Elev.		~20 ft			Zoom	Wide Angle			

This is my favorite "leisurely" hike in the park – very best enjoyed in the late afternoon prior to sunset. Whether you're staying at the National Park Inn (at Longmire) or not, pair this hike with an upscale park dinner at the inn. You'll not be disappointed.

Trail of the Shadows is particularly wonderful because it offers so many unique subjects for the photographer. Photos taken here will add a nice variety to your Mount Rainier National Park portfolio.

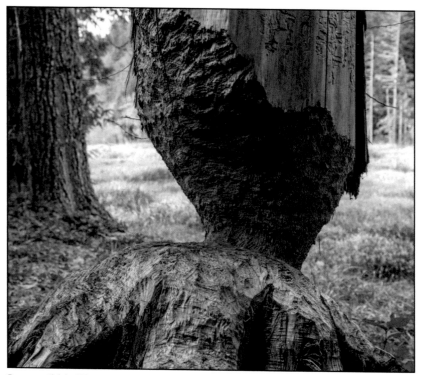

Beaver-nibbled Tree 35mm f/5.6 1/80s ISO200

Most compositions along this trail may be made with a wide angle zoom. If you're out during low light conditions, and you need to stop down for depth of field, a tripod will be useful. I've always left my tele-photo lens behind on this one, but at times some deer have appeared in the open meadow, so if the chance of capturing them is important to you, also pack along your long glass.

There are multiple entrances to this trail across the main park road from the inn. Any entrance will do. It's best to walk this counterclockwise. (So if you've just crossed the road and have found the trail parallel to the road, take a right.)

Very soon after you begin your walk, you will see a path on the left that takes you to a viewing platform near the perimeter of the oblong and very marshy (wet) meadow. The loop encircles this meadow.

Most of the "landmark" sights along this trail are located in the next 1/8 mile or so. So, back on the main path, your first curious, old subject is the rock-ringed Soda Springs, an active hot spring. Though not wonderfully photogenic on its own, this is a great place to take a group photo (if you're on the trail with others), as it feels very natural for many people to sit or stand around the rock formation.

Continuing on, and perhaps thanks to some resident beavers, is a small area of less densely-packed trees. Here, if you glance to your left you will see a popular sight – a tree that *almost* found its fate on the ground, thanks to these beavers – but not quite yet. (This is the tree pictured on the prior page. I hope it's still there during your visit!)

On further, back under the more dense canopy, you will come upon a restored and very small log cabin, used at the turn of the century to house personnel at the resort. Some good news – that cabin door opens! Look inside, and consider some compositions there as well.

Back on the trail, we come to "Iron Mike," another hot spring, but this one has all the right stuff for the photographer – most notably its vivid orange rust color and an abundance of wonderful textures and complimentary colors. It takes an ultrawide lens to really take it all in, and immerse your viewer into the photo. For the Longmire section photo of Iron Mike, I was on a tripod, and only inches off of the ground. Get low!

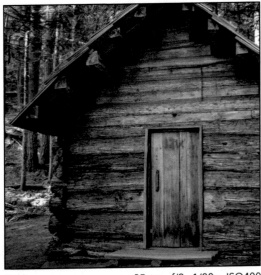

Cabin 35mm f/2 1/80s ISO400

Time to leave the man-made structures behind (well, except some small wooden foot bridges), and continue the loop. You're on the north end, and now walking south, you follow the flow of water through the adjacent meadow, and see how it impacts the landscape and resident vegetation.

Rampart Ridge is to your right, and thanks to its grade the trees here are better protected and grow larger than the ones on the opposite side of the meadow by the inn. And there are some big ones in here.

There's a section of this trail, somewhere between the middle of the meadow at your left and the meadow's far south end, where the trees are very often in fog. For this book's sake, we'll assume there's a perfectly normal scientific explanation for this, but having walked this trail many times, it's surprising how often this finite area of trees has fog around it, where nowhere else on the walk does. ...No need to go off-trail to see this. If it's there during your visit, you'll know it, and I'll let you draw your own conclusions on its presence.

Mysterious Fog 35mm f/2 1/50s ISO400

Moving on again... You will loop the south end of the meadow where now the water continues its journey out of the mountains. Here find both an interesting bridge and plant life in this extremely soggy area. (Another potentially interesting composition of park foliage and structure [the bridge].) Not many strides later, you approach the main park road that you initially crossed. The loop is complete.

Time Best Good	☀ ☀ ☀ ☀ ☀ ●	Reward ✹ ✹ ✹ ✹
Budget 45-60 min	**Type** Meandering	**Effort** L L L L L
RT Distance <0.5 mi	**Δ Elev.** <60 ft	**Zoom** Normal

If photographing rustic stone and wooden buildings is your thing, this is the place! I'll explain building-by-building, and then finish with a well-hidden bridge...

The **National Park Inn** is the lead act, and probably the first building you noticed as you entered the area. Its grandiose front porch with an abundance of rocking chairs is really inviting!

Its porch and the multiple footpaths in front of the inn are great places to capture the setting sun's last light on Mount Rainier. The perspective is right, as this is one of the more westerly areas within the park (with a view of the mountain). For years, clear visibility eluded me, but on a recent visit I was delighted to finally see it. If your luck is down too, but the mountain is visible (perhaps hazy), here's a fun trick to at least try out: Switch your camera's white balance to Manual, and adjust the Kelvin setting to almost as high or as high as it will go (such as 8000 K).

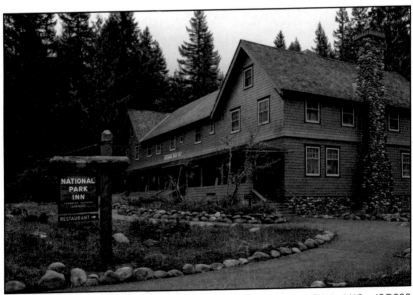

Early Autumn at the National Park Inn 35mm f/5.6 1/13s ISO200

If looking at the front of the National Park Inn from the street, the **General Store** is to its right. It's a charming little log cabin with log benches on its covered porch.

To the left of the National Park Inn, separated by some trees, is a retired **Fuel Station** with two red, antique "visible" style gas pumps. If a wide view of this landmark doesn't seem to work, try getting in close to the pumps and capture their details instead.

Then left of the Fuel Station are some restrooms. (No need to photograph these.) But to their left is the **Longmire Museum**. Due to its very small size, it can at times be crowded inside. The museum's primary presentation is of the park's birds and land animals. It's worth a visit, but if the crowd appears suffocating, no need to wait – just move on.

And lastly, of the buildings to cover, is the beautiful **Longmire Administration Building** – a combination log structure with a facade made also of very large stones. This building is the northern-most along the main road of these structures. Back to the partial stone construction... Nowhere have I ever seen stones this large used on a rustic building (in this manner). Be sure to take a close look, and consider capturing these stones' significant size in your picture.

Now for a "hidden" gem – the **Longmire Suspension Bridge**. To access this bridge, you will need to walk down Longmire Road, into the park staff's quarters area. (Longmire Road is the road between the Museum and the Administration Building.) Please be especially mindful that you are walking now through in essence people's "neighborhood." Please be respectful of this space. Your journey, one way, will be about 1/8 mile.

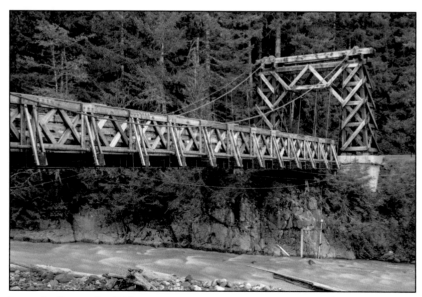

Longmire Suspension Bridge 50mm f/16 20s ISO400

Time	Best Good							Reward	✸ ✸ ✸ ✸

Budget	1.5-2.5 hr	Type	Out & Back	Effort	👣 👣 **👣 👣 👣**

RT Distance	~2.2 mi	Δ Elev.	~500 ft	Zoom	Norm, Tele

I'm going to cut to the chase on this one – unless the National Park Service decides to clear some limbs at the viewpoint of Carter Falls (and I wouldn't expect them to), you will not be able to photograph the falls in the classic sense (unobstructed from its top to its bottom).

But wait! Through gaps in the foliage, you can use your telephoto lens and capture some amazing detail of the water-worn and moss-laden rocks, as well as a rainbow in the fall's mist if you're there in the mid-afternoon.

And bonus – this is also a really nice hike with a good variety of terrain and sights along the way. You will begin by crossing the Nisqually River over a log footbridge, and then disappear into dense woods adjacent to the Paradise River. (The falls are on the Paradise River, not the Nisqually River.)

Crossing the Nisqually River 35mm f/5.6 1/400s ISO50

Once in the woods, it starts off relatively flat for a little bit, but then here comes the ascent. Rest, as required, though my advice is to hold off from taking photos along the trail until your return trek, as the lighting will be better. (More on this shortly.)

Nearing your destination, you will see a sign that announces Carter Falls, but also makes mention of another waterfall just 50 yards further, Madcap Falls. Unlike Carter Falls, Madcap Falls is capable of being photographed, but there are several large, fallen trees at its bottom, and afternoon lighting can be difficult. So while it's worth a picture or two, I believe you're better off spending your time and energy working to capture the magic of Carter Falls. Don't get me wrong, make use of your climbing momentum, and go check it out first, then return back to Carter Falls for the rainbow in its mist.

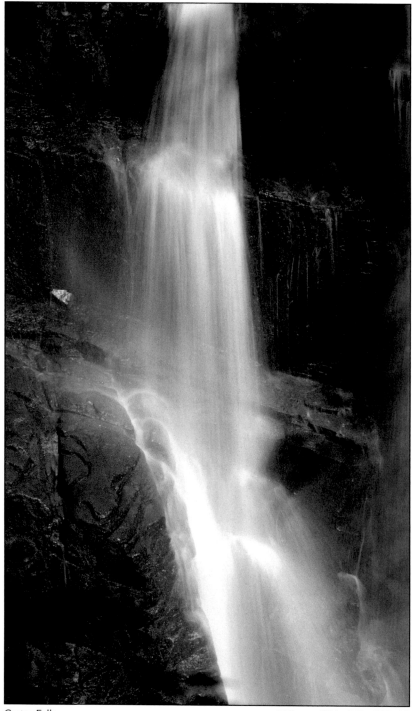

Carter Falls

135mm f/16 1/4s ISO100

Back down at Carter Falls, I set up my tripod at the large, downed tree at the trail's edge. Attach the telephoto lens, find a gap between the limbs to shoot through, and zoom in. This waterfall has so many rocks with wonderful texture and color.

Because the fall is relatively vertical and misty, as the sun drops in the sky, a rainbow will first appear at the bottom, and slowly work its way up. In mid-summer, this occurs between 3:15-4:45pm.

Something fun to also try here, zoom in to 300mm or 400mm and frame the details of the moss and the weathered rocks alone. Adjust your shutter speed to 1/1000s and catch the small water droplets mid-air. This technique allows for a composition with an abundance of very interesting textures.

Once it's time to head back down, now keep an eye out for the other trailside subjects, and with more interesting, longer shadows now that it's a bit later in the day.

Near the bottom, there is one boulder that very closely resembles Star Wars' Jabba the Hutt. The boulder is even the right size! So if you're a Jabba fan, this might make for a fun self-portrait.

Finally, make your way back across the bridge, and time for your next destination! *(Or perhaps a pleasant nap before dinner.)*

Jabba the Hutt? 28mm f/4 1/50s ISO200

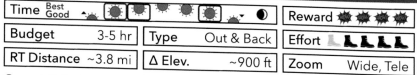

Time	Best Good									Reward	🌟 🌟 🌟 🌟
Budget		3-5 hr	Type		Out & Back	Effort		👢 👢 👢 👢 👢			
RT Distance	~3.8 mi		Δ Elev.		~900 ft	Zoom		Wide, Tele			

Comet Falls is among the best (some would argue *is the best*) in the park, but unlike Christine Falls and Myrtle Falls it requires some considerable effort to get there.

The trailhead has its own, small parking lot on the north side of the road just west of Christine Falls. It typically fills by mid-morning. If you follow my recommended "best" time to arrive at the falls you will beat the crowd.

The lighting is somewhat critical here on sunny days. If arriving at the falls during the early morning a rainbow is common in the falls' heavy mist. Ideally you arrive early enough to "work" with the rainbow from different vantage points. Arriving late, and it may be gone. Once the light is directly overhead the various scenes are a bit harshly-lit. Alternatively, working later in the day the entire scene is shaded, and while not as dynamic it is easier to manage.

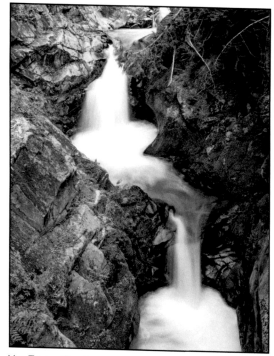

Van Trump Creek 35mm f/11 1s ISO50

The trail immediately climbs, to reach a bridge over Van Trump Creek at 0.3 mile. Looking downstream, you can see the road as outlined on the Christine Falls (6) narrative. An upstream view provides the first, best composition along the hike.

Once on the other side of the bridge, the trail continues parallel to the rushing water, gaining elevation.

After some remarkable climbing, at about 1.0 mile it levels off into a clearing with a nice view of Mount Rainier.

Along the way, and especially close to the end, are several boulder fields. American pika, a smaller-size relative of rabbits and hares, are regularly seen and heard here. This is one of the opportunities to use a telephoto lens, if you brought one along. They're cute.

Finally, after the larger, steep boulder field you arrive at and cross lower Van Trump Creek. If Comet Falls weren't so magnificent, given your unrealized-of-yet proximity, I would recommend to photograph the falls adjacent to this crossing... In other words, bury the temptation and continue on. (If time permits, photograph this on the way back.)

A short climb leads you to within clear sight of your target destination, Comet Falls. This is a comfortable, shaded area for telephoto work of the three waterfall tiers of the greater Comet Falls area.

Onward and upward more, zig-zagging a few final switchbacks near the end you will reach a very informal "viewing area," to the left of where the trail makes a hard right up a hill and away from the falls. This trail leads you to Van Trump Park (not covered within this narrative), so do not make the right turn. The viewing area to your left is an open space of exposed soil and rocks, usually wet from Comet Falls' persistent mist. Photography from this well-trafficked, broad area is possible, but it can be a real struggle to cope with the abundant mist on your camera lens. So instead, if you feel capable doing so, follow one of the few narrow paths up the grassy hill to a slightly higher vantage. Please be careful not to creep close to the steep dropoff... Remember the area is slick from the mist. From here is where I captured the shot on the opposite page.

I used a ND filter to allow for a shutter speed of 2 seconds... I like the result, but I also liked the result from my settings with a shutter speed of as fast as 1/200 second. This is a waterfall that looks good under a variety of shutter speeds, so be sure to experiment a little.

Once satisfied with your work and time to head back, just prior to your approach of the single log "bridge" you traversed near the wide, middle fall is a trail down to upper Van Trump Creek. It is passable; just take your time and be prepared to hike with your feet and hands at times for stability. I enjoy this perspective of the close-up middle waterfall with the taller waterfall behind. This is a good space to try varying wide angle focal lengths and distances from the middle waterfall for different compositions. ...Curiously, this is the composition of the falls on the trailhead's reader board, but on the reader board the photograph is a mirror image! Whoops. Clearly a mistake.

And that's it! Check your time and your itinerary – this venture takes longer than expected. With what you have left in your schedule's budget, explore some of the other water features on the way back.

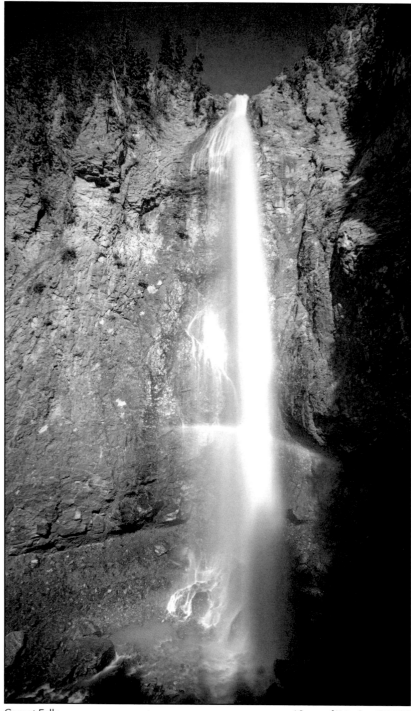

Comet Falls

18mm f/11 2s ISO100

Time	Best		Reward	🌟 🌟 🌟 🌟	
Budget	45 min	Type	Roadside	Effort	
RT Distance	<500 ft	Δ Elev.	~20 ft	Zoom	Normal

I would venture to bet that if any Mount Rainier National Park publication has 3 or more photos printed in it, one of those 3 photos is Christine Falls. Its publicity is earned; it is a beautiful composition.

Time of day is very important here, because once mid-day sun strikes these falls and this area, it's no good. Sad, but true. So, schedule a day to visit this area early morning to ~9am, or in the afternoon after ~4pm. I recommend to head here after you have completed your sunrise work. (There are multiple, recommended sunrise locations around Paradise, so start your day there, then head back west to work Christine Falls.)

Not until I arrived at Christine Falls for the first time was it evident to me that the stone bridge in the picture is a two-lane bridge that you drive over. So the bridge, as you drive through this area, is your waypoint. There are two parking areas near the bridge – one is on the east side of the bridge (towards Paradise). It is the main parking lot serving the area. The short trail down to the viewing platform leaves from here. The second lot is on the west side of the bridge, and is primarily there to serve hikers on the Comet Falls Trail to Van Trump Park. As such, the west parking lot tends to fill early in the morning, but it opens up in the afternoon, as hikers return to their cars. That hike and these waterfalls are popular destinations, so consider a contingency plan if there is no parking on your first attempt.

Waterfalls (plural) – did you catch that? The lower one is epitomized by this classic photo, and the upper ones are seen from the road (and the bridge). The point is this – while your primary destination is the overlook, below the elevation of the bridge, do not skip on walking up to the bridge and seeing the upper falls as well.

You definitely will want to employ your tripod for this shot, as well as a neutral density filter if you have one. Try framing the shot from different places along the wooden safety rail, as well as using a variety of focal lengths. Your "ideal framing" may not be evident until you are looking at the pictures you've taken on a larger screen.

One final tip for this shot... Utilize the bridge top (its horizontal element) as your photo's level. It's close enough to the natural horizon for you to use it like this.

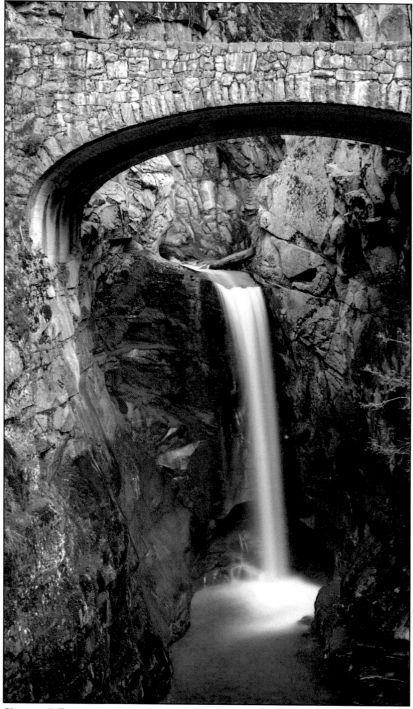

Christine Falls

55mm f/4 30s ISO200

And finally, as noted earlier, do walk up and see the upper falls and the visible wooden footbridge serving the Comet Falls Trail. This may take second place to the lower fall and bridge, but it's still serene.

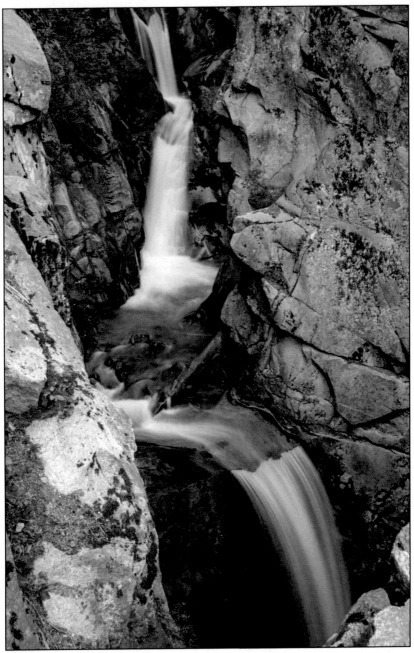

View from the Bridge 28mm f/11 1s ISO100

Paradise

Narada Falls to Louise Lake

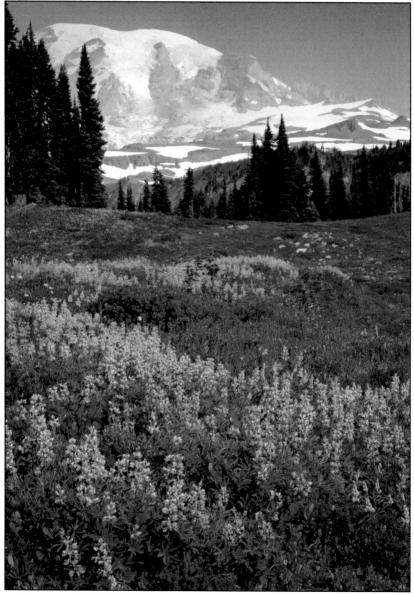

Along the Skyline Trail 28mm f/8 1/500s ISO100

Time Best Good		Reward
Budget 45-60 min	Type Out & Back	Effort
RT Distance ~0.5 mi	Δ Elev. 150-200 ft	Zoom Normal

No Mount Rainier National Park guide book would be complete without mention of Narada Falls. As such, it has earned 2 pages here, but with some real caveats.

My issue with Narada Falls is that its lighting is uneven and quite unpredictable. This is due to the profile of the mountains to its immediate south. I have tried numerous ways to tackle this, but every time it felt as though the reward didn't match my effort. To say it differently, I could have spent my time better elsewhere *as a photographer*. And therein is the gotcha – if you're with family and want to take in a grandiose waterfall, no matter the harshness of the lighting, then walk the trail and have a look. It is fascinating.

But now perhaps you're thinking, "Hey that shot below looks great! What's all this about bad lighting and little reward?" This was taken from the river, below the falls, and the hike was very slippery.

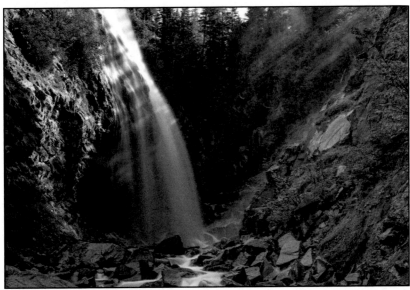

Morning Beams of Light on Narada Falls 40mm f/11 1s ISO100

It's passable, as the National Park Service regularly showcases this same photo angle, but please know your limits if you choose to go. No photo is worth trekking beyond your physical abilities.

The typical perspective is from the viewing platform, directly in front of the falls. With some luck, you'll see a rainbow in the mist. The challenge here is that the platform is also engulfed in mist, so keeping your equipment and lens glass sufficiently dry can be a real challenge. (And a potentially expensive mistake, if your camera and lens kit is not adequately water-resistant.)

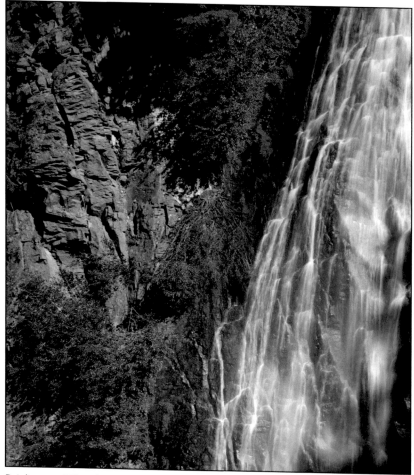

Rainbow and Narada Falls 70mm f/11 1/6s ISO100

So my advice is this... When you're driving by the Narada Falls parking lot, pull in and park. Don't load up your equipment just yet, but instead walk over to the stone wall at the edge of the parking lot, have a look down at the lighting conditions, and consider then if it's right for you and warrants the trek down. If not, hop back in your car, and wait for the next time that you find yourself driving by Narada Falls. Perhaps one time, the lighting will be just right.

Time Best Good	☀	Reward 🏵 🏵 🏵 🏵		
Budget	4-6 hr	**Type**	Loop	**Effort** 🏋🏋🏋🏋🏋
RT Distance ~5.5 mi	**Δ Elev.** ~1,700 ft	**Zoom** Wide, Tele		

I'm not sure what exactly constitutes a "day hike," but I'm fairly certain the Skyline Trail qualifies as one. There are only 2 others in this book 4+ hours (32 & 35), and I've kept these types of hikes at a minimum, because my goal for you is to see more of the park in a short amount of time, than spending an abundance of hours on just a few trails. If you have the time, this one is definitely worthwhile. Do study the area trail map – there are short, parallel trails adjacent to the "main" Skyline route if, for example, you learn of wildflowers somewhere in bloom.

For photographers, this hike is at its best with wildflowers. Therefore, if the timing of your visit is off (and there are no wildflowers in bloom), then I recommend using your time elsewhere. (See the Tips & Techniques section on specific wildflowers advice.)

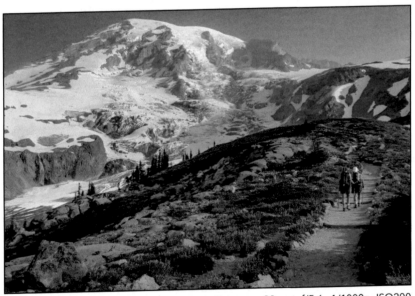

Climbing the Skyline Trail towards Panorama Point 28mm f/5.6 1/1000s ISO200

Plan to begin this hike early – ideally, just after sunrise. Pack plenty of water (3 liters, plus or minus, as you might expect to consume based on prior experience), and dress in layers. While it may seem cool or cold to begin, as you ascend and the sun warms things up, you will be shedding layers.

I have hiked this with a tripod, and a bit to my disappointment, I could have done without it, with the exception of its use at Myrtle Falls near the end of the loop. So, for your consideration – if you would like to shed the weight and go without, but then double-back after you have finished from the parking lot with your tripod, to capture Myrtle Falls, this might be the best strategy. (This assumes your lenses and/or camera have built-in stabilization, suitable for hand-holding all but the very slow shutter speeds desirable with waterfalls.)

To hike the Skyline Trail clockwise (recommended), from the Paradise Visitor Center head up the granite staircase and follow the trail signs for the Skyline Trail (usually continuing straight ahead and directly uphill). It gets steep immediately. Fortunately, this intense grade is not constant throughout the hike!

Be on the constant lookout for Hoary Marmots. They like to soak-up the early morning sun on the large boulders that you will be frequently walking past.

Your choice to take any of the parallel trails that tie into Skyline (such as Alta Vista, Deadhorse Creek, or Glacier Vista), but my advice (unless you have received updated information) is that your best strategy is to stay the course and bypass these.

100mm f/5.6 1/500s ISO200

Your first major milestone is Panorama Point – a great place to stop and take a well-deserved break. Plus, you have an amazing viewpoint of Cascade Range volcanoes to your south, including Mount St. Helens and Mount Adams. If it's not too hazy, have some fun with your telephoto here. Also, turn around and look up Mount Rainier. Scan the features in the distance – you can now clearly see Camp Muir through your telephoto lens. Can you see silhouettes of people too?

Camp Muir 300mm f/8 1/400s ISO100 (then 2:1 digital crop)

The rest stop is over... Back on the trail. Up and down, across creeks with wildflowers in bloom at their flanks. Enjoy the variety and differences in terrain along these higher elevation areas.

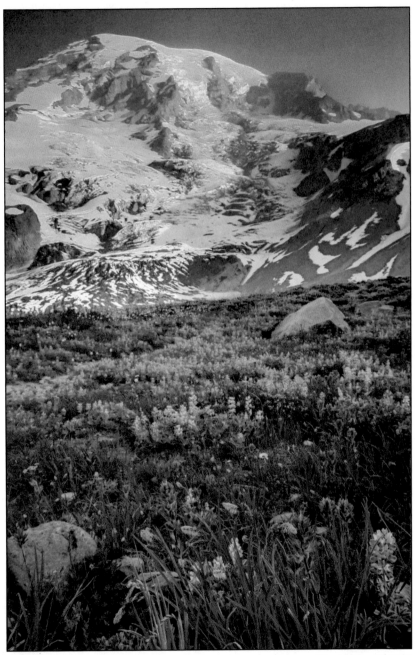

In Full Bloom 28mm f/8 1/400s ISO200

Perhaps my favorite spot along this hike is as you're making your way down from peak elevation (walking south and approaching the upper junction of the Golden Gate Trail), you will see a lush greenery along upper Edith Creek. Here's another great place to stop, and experiment with some different compositions.

Upper Edith Creek

16mm f/22 1/25s ISO50

Once moving again, the next option is to take this Golden Gate Trail or stay on the Skyline Trail towards Sluiskin Falls. The primary consideration here, is where are the wildflowers reported to be showing best. If you're advised that Golden Gate Trail is the place to be, then deviate, and follow that path. Otherwise, stay on Skyline, and you're likely to see some along there too, because the elevation and sun/shade changes frequently, so an abundance of wildflower areas will be along your path.

Some "unfortunate" news – Sluiskin Falls is not a photographer's stop. Your vantage along the trail just won't allow a worthy shot. Enjoy its sound, and march on.

Finally, some more down then up, and you arrive back near the Paradise base area. This is where the legs really scream for mercy, but hopefully you have some worthwhile photos to stop for along the way and enjoy occasional breaks.

I'll cover Myrtle Falls in the next section, so check there for information on this beautiful location.

Time to go rest your legs a while!

Time	Best Good							Reward	💥 💥 💥 💥
Budget	1-1.5 hr		Type		Out & Back			Effort	👢 👢 👢 **👢 👢**
RT Distance	~1 mi		Δ Elev.		~160 ft			Zoom	Normal

Myrtle Falls is truly unique, because you can frame it *along with* Mount Rainier in the background. No other waterfalls in this book allow for this composition.

Technically, Myrtle Falls is the single ~70 ft drop, downstream of the log foot bridge, and with a viewing area down some asphalt / log "stairs."

But an equally impressive (and easier to frame and access) cascade is right at and immediately upstream of this same log foot bridge.

Of the two compositions, the cascading water shot shown below is much easier to compose, due to clear access and lack of foreground clutter. But of course, you must still take both shots!

There's no real "trick" to taking either of these photos. Only, if the areas are crowded, you may need to be patient for space to open-up in order to set up your tripod.

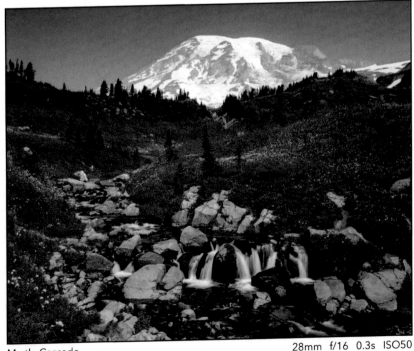

Myrtle Cascade 28mm f/16 0.3s ISO50

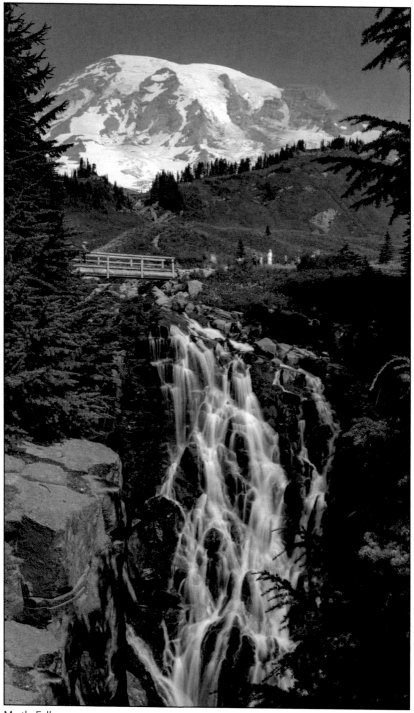

Myrtle Falls

35mm f/22 1/4s ISO100

If you have already studied the Paradise area trail map (as described on page 28) or happen to be looking at one of the trail map reader boards in the Paradise area, you will notice there are very many trail options at your disposal. Two, in particular, could warrant their own site narratives – Nisqually Vista Trail and Alta Visa... But I didn't. Instead, I will provide a brief insight to these and most of the rest here instead.

★**Nisqually Vista Trail:** From the lower, boomerang-shaped parking lot this trail is 1.2 miles round trip with 200 ft elevation gain. If beginning at the Visitor Center, figure an additional 0.6 mile on the round trip and another ~50 ft of ups and downs. The trail is entirely paved and shaded the majority of the way. Some of the sections are unusually steep, for an asphalt path. There are four vistas on the north side of the loop, showcasing the Nisqually Glacier, its terminus, and surroundings. I recommend hiking the loop clockwise.

Avalanche Lily Trail: The Avalanche Lily is a common, white wildflower that grows in large patches. This is "connector"-type trail. In the fall it is a good, easy path to explore for vibrant color and compositions.

Waterfall Trail: This name escapes me. There are no waterfalls along this short trail. Best I can figure is it serves as another connector trail between Myrtle Falls and to other trails that provide views of the Nisqually Glacier and its adjacent, *albeit distant*, waterfalls into its ravine.

Moraine Trail: The first of two I recommend skipping. It is an out-and-back and views "as good" can be had from the more-efficient-with-your-time Nisqually Vista Trail.

Deadhorse Creek Trail: This trail section, given the right timing, features abundant wildflowers. It parallels the Skyline Trail (8). Ideally, if hiking the Skyline Trail, inquire at the Visitor Center which of these two sections has the most abundant wildflowers in bloom, and choose accordingly.

Glacier Vista: I also recommend to skip this detour. Unfortunately, given the last few decades' significant recession of the Nisqually Glacier, it is underwhelming. At one time, it was undoubtedly remarkable.

★**Alta Vista:** I like this trail and have been on the fence to include it as a standalone site in this book. Clearly I haven't yet, but it is worth consideration if looking for perhaps an alternate to the more involved Skyline Trail. If making a loop from the Visitor Center using its westerly parallel of the Skyline Trail it is 1.8 miles round trip with 600 ft elevation gain. I recommend to walk this loop clockwise. Once at the "peak" of Alta Vista, you are presented sweeping views of the Paradise area – all more close-in-view than the up-mountain Panorama Point.

Golden Gate Trail: It may not be evident from the maps, but this trail's true purpose is to serve as a shortcut from the Skyline Trail to the Myrtle Falls (9) area. It shaves ~1.5 miles off the otherwise "complete" Skyline Trail loop, making for a 4 mile loop in total. This is an enticing option, as the majority of the good stuff on the Skyline Trail, if hiking clockwise as recommended, is already covered.

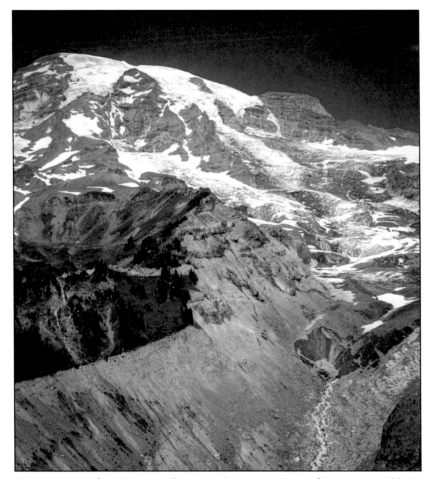

Glacier Terminus from the Nisqually Vista Trail 50mm f/5.6 1/640s ISO100

The Paradise area offers a lot. You could easily lose yourself an entire day here. If willing and able, my favorite route remains the Skyline Trail. Sure, your legs will likely be exhausted afterwards, but you will have experienced what I think encompasses *all* of the best of Paradise.

If Skyline's 1,700 ft elevation gain is too much to bear, then hopefully this roundup of alternative options will help you plan your own route through this marvelous area.

Time Best/Good		Reward
Budget 30 min	**Type** Roadside	**Effort**
RT Distance <200 ft	**Δ Elev.** <10 ft	**Zoom** Norm, Tele

Sunrise or "first light" shots can be magical, but some days it sure is nice to capture that magic with the warmth of your car in arm's reach. Here is one of those compositions, where you don't have to bother with an off-road hike to get that precious, soft morning glow.

There's not a lot to obtaining this shot – just the knowledge that it's there waiting for you, most summer and early fall mornings, while the roads are accessible. This really is "roadside," as if you have just left the Paradise Visitor Center area, and are heading in the direction of the one-way, clockwise-direction road that leads back down towards Ruby Falls.

Do occasionally turn around, and see how the light illuminates the Tatoosh Range behind you (especially Pinnacle Peak and The Castle).

First Light on Paradise Inn 35mm f/8 1/80s ISO100

Something fun to look out for... Using your super-telephoto (300mm and longer), occasionally check for signs of hikers working their way up to the summit of Mount Rainier. You might just see a group's silhouette!

Time	Best Good							Reward				

Budget	30-45 min	Type	Roadside	Effort

RT Distance	<200 ft	Δ Elev.	~20 ft	Zoom	Norm, Tele

You won't find Ruby Falls listed on very many maps, but that's not a problem, because it's one of the easiest sites to find. It's part of the Paradise River flow, upstream from Narada Falls, and right at the junction for the turnoff that serves the Paradise area. There are parking pullouts on both sides of the road where it goes over the river.

The cascade you'll notice first from the car is on the east side of the road. It's pretty, but occasionally has some challenging lighting. No less, park the car, and let's explore more on foot...

If you'll now walk to that east side of the road and look straight down, check out the gorgeous textured rock and flow below! This is unique, and easy to have fun with some long exposures. Experiment!

If you cross the road, you can walk down to see the falls' more magnificent drop. Take the south-side trail. (Left bank, if you're following the flow of water.) Whoa, this fall produces some major mist! Plus, there are areas for you and your tripod at multiple elevations here. And the final bonus – downstream faces nearly due west... (Do you see where I'm going with this?) This is rainbow-making material here!

So if capturing a rainbow within a waterfall is on your bucket list, this is an excellent place to try. It's extremely easy to access, and the "control" you have with the variations in your shooting height (relative to the position of the sun behind you in the late afternoon)increases your odds substantially!

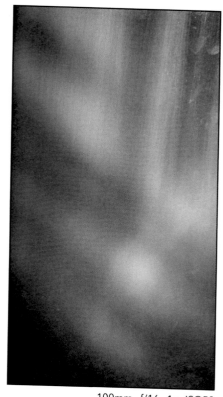

100mm f/16 1s ISO50

Time	Best Good								Reward	🌟 🌟 🌟 🌟
Budget	45-60 min		**Type**		Out & Back		**Effort**		👢 👢 👢 👢 **👢**	
RT Distance	<0.2 mi		**Δ Elev.**		<40 ft		**Zoom**		Normal	

I doubt that I need to promote this shot – in all likelihood, you've seen it before – oh yes, I remember now – on the cover of this book! This is again one of the "quintessential" Mount Rainier National Park compositions.

And isn't it wonderful when the beautiful pictures are relatively easy to take? This one is. The only "pain" is having to roll out of bed early, but that's really it! OK, there are a few tricks. So let's take them one at a time...

There are two lakes, side-by-side. You want the larger one (to the west). *OK, that part was easy!*

This is at its best a sunrise location, and for two reasons. 1) Because sunrise is awesome, and your view from the lake to the mountain is best this time of day. 2) I have only ever seen calm lake water very early in the morning. (Unfortunately, I've seen very many frustrated visitors at the lake later in the day, only to see lake water that is not at all calm, with no visible reflection of Mount Rainier.)

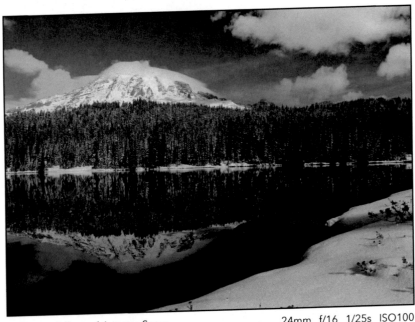

Reflection Lake and Autumn Snow 24mm f/16 1/25s ISO100

Your ideal position is at the water's edge. By doing so, you can maximize the size of the reflection in your composition. So, get as close to the water's edge as is practical, safe, and not harmful to the lakeshore.

Finally, and perhaps the best advice that I can give here, is that since you need to be close to the water, and there before sunrise (i.e. in the dark), I highly recommend scouting-out the area the day before. (Gaining a clear understanding of the area prior will also help orient you on where best to park and then which trail to walk, instead of also having to figure this out too in the dark. Trust me – I learned all of this the hard way on my first visit!)

Good luck – may the clouds and lighting be in your favor!

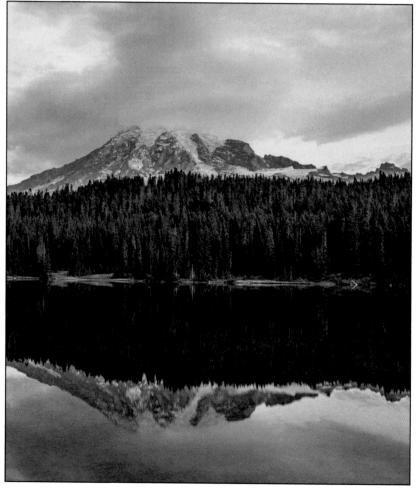

Reflection Lake 24mm f/16 4s ISO50

Time Best Good		Reward 🎇 🎇 🎇 🎇
Budget 2.5-3.5 hr	**Type** Out & Back	**Effort** 👢 👢 👢 👢 👢
RT Distance ~3 mi	**Δ Elev.** ~1,200 ft	**Zoom** Norm, Tele

For an enjoyable hike and an elevated, alternative view of Mount Rainier from its south side, Pinnacle Peak is a great option.

Much of the trail is rocky and loose, so lace up your more sturdy footwear with a rugged sole for better traction. Also consider trekking poles, perhaps especially for your return back down where the strike of your heel finds loose rocks and slipping occurs.

The trailhead is on the other side of the road from the west parking lot at Reflection Lakes (13). A reader board provides a topographical illustration of the route and peaks ahead.

Once hiking, find your pace, but realize that over the course of the ~1.5 miles up that the grade does increase slightly all the way to the formal ("maintained") trail end at the saddle between Pinnacle and Plummer Peaks. (Pinnacle Peak is on your left as you approach, and Plummer Peak is on your right.)

Once at the saddle, check out the views from the side you just hiked up and also the backside. This is a fine place to take a break and a lot of pictures before turning around, OR scramble up the west (saddle-side) ridge of Pinnacle Peak...

If proceeding, be careful — consider that every rock you step on could be loose. Many are. Once at the ridge, the dropoff is high and could be fatal. Many people trek towards the top; just know your limits.

The Scramble Up 28mm f/11 1/320s ISO100

Snag and Lingering Snowpack 24mm f/16 1/100s ISO400

With your panorama vistas from both sides of the saddle and on top (if you choose to proceed) there are an abundance of great compositions to be made.

Lastly, always be on the lookout for wildlife, as many larger animals frequent this area. (This is the primary reason for bringing the telephoto lens, though it's also fun to zoom-in on the distant features of Paradise.)

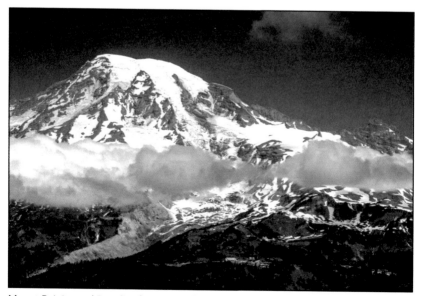

Mount Rainier and Paradise from Pinnacle Peak 50mm f/5.6 1/800s ISO100

Time _Good_	Reward	
Budget 30-45 min	**Type** Out & Back	**Effort**
RT Distance <0.2 mi	**Δ Elev.** ~90 ft	**Zoom** Wide Angle

Louise Lake ≠ Lake Louise, a landmark mountain lake in Banff National Park (Alberta, Canada). Let's be right on the name!

To me, Mount Rainier National Park's Louise Lake has a sort of gravitational pull to it. Every time you drive past it, it's as if it is summoning you to visit. I suspect this is because, as we are in our cars, its downhill, and that perspective makes it somehow mysterious.

So one day I did finally stop. Now, it's not a "must see," but if you do have 30-45 minutes to spare (and time of day isn't really critical), then go check it out.

Accessing it is straightforward. Park where you can and it is safe, but essentially you will find yourself on a section of the Wonderland Trail parallel to the road. Off the trail, in the direction down towards the lake, will be your trail to follow.

Once at the edge of the lake, the most interesting compositions are low to the ground, and with a wide angle lens. Depth of field can be a challenge; you'll see that I had to stop down a lot to bring both the foreground and background into focus. Tripod recommended!

Louise Lake 24mm f/22 1s ISO50

Stevens Canyon

The Bench to Backbone Ridge

Fall Color along Stevens Canyon Road 70mm f/8 1/200s ISO200

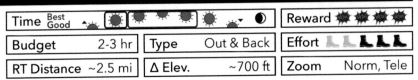

Time Best Good	☀ ☀ ☀ ☀ ☀ ☽ ◑	Reward ✸ ✸ ✸ ✸		
Budget	2-3 hr	Type	Out & Back	Effort 👣 👣 👣 👣 👣
RT Distance ~2.5 mi	Δ Elev.	~700 ft	Zoom	Norm, Tele

also known as "Bench and Snow Lakes Trail"

I'm delighted to rewrite this section with updated information. In my prior editions I identified that the water levels, especially at Bench Lake, play a critical role in what you can achieve as a photographer. Having returned multiple times since, I realize that my earlier scouting efforts were atypical... This is good news. (Water levels cannot be guaranteed, but in all likelihood they won't pose issues for your visit like they did for me before.)

The trailhead is easy to find and has a dedicated parking area. The hike seems to have grown in popularity over the last few years, so parking can be a challenge, but typically only if arriving after 11am or so.

What is "The Bench?" It is a flat area – a meadow, of sorts – that, is bound by the Tatoosh Range to its southwest and Stevens Canyon to its northeast.

The trail begins its climb to The Bench immediately, and after about 0.3 mile you reach the meadow. I find this area wonderfully unique. Curious trees, abundant wildflowers, and my only experience within

The Bench 35mm f/11 1/80s ISO200

Mount Rainier National Park to encounter very many hummingbirds. Also, there is a meandering stream at The Bench's lowest elevations, but be careful not to get too close, as the ground can be very soggy.

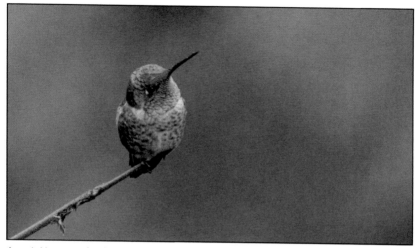

Anna's Hummingbird 400mm f/8 1/500s ISO200

As you continue on, you will lose some of the elevation that you worked for in the beginning... At about 0.6 mile you reach a small intersection with a sign directing you to the left for Bench Lake. Unfortunately, the path down to the lake is a bit steep and uneven. Stow your gear and use your hands along the way to steady yourself

Bench Lake 35mm f/8 1/200s ISO100

where necessary. There is a "T" – take a right, and work towards the lake's south shore. Here is where, if the water level is low enough, you can traverse the shore and make your way around to find a brilliant scene with Mount Rainier in the background.

Admittedly, this scene strongly resembles that of Reflection Lake. If you're not careful with your portfolio they can be accidentally swapped! One significant (and fortunate) difference between the two is that Bench Lake tends to be more forgiving during the middle of the day with calm water for providing the desirable reflection. Sure, Bench Lake could make for a great sunrise composition, but Reflection Lake is as good and a whole lot easier to get to in the dark! Plus, with Bench Lake's regularly-calm water your timely arrival is not required. (Sure, if it's a windy day, all bets are off on both sites!)

Once finished with Bench Lake, climb back out to the main trail and follow the sign to Snow Lake. Prepare yourself – while the grade begins downhill from this prior intersection, it is about to require an uphill effort, the most steep section of the journey. At about 1.0 mile you close in on Snow Lake, and your uphill battle is complete.

Snow Lake 24mm f/16 1/60s ISO400

As you descend towards the lake you will encounter an intersection; either make a sharp left turn at the signage towards Snow Lake Camp, or continue straight towards the nearest shore. My advice? Head to

the nearest shore.

This water's edge is rocky, and while challenging in places to navigate, the rocks can provide for an interesting foreground in your composition. Some area exploration (including trial and error) will be required.

The trail does continue a bit further, southwesterly, towards a boulder field. I have explored this, and it becomes impractical to traverse. It's not far if you are interested in having a look, but don't expect to find a convenient path elsewhere along the lake's south side for a better composition.

Once finished with Snow Lake, head on back the way you came. If a second look at Bench Lake is desired, then trek down the steep path again... You know the way now.

Scarlet Paintbrush 200mm f/5.6 1/1600s ISO100

Time Best Good		Reward		
Budget	1-2 hr	Type	Out & Back	Effort
RT Distance ~1.1 mi	Δ Elev.	~500 ft	Zoom	Wide Angle

For the waterfall aficionados, here's one that is accessible via a reasonably-short hike, and one that most people leave off their list, in favor of peering at it way from the distance on the Stevens Canyon Road. (As you might expect, its beauty is totally missed from that far away. So come in close, for a better look!)

There is one potential challenge here though – finding the trail entrance off the road. Ultimately, you're looking for the Wonderland Trail on the east side of the main park road.

Begin from the obvious hairpin turn, up near The Bench. Drive downhill on the road, towards Stevens Canyon. Pass one pullout on the right. The next pullout on the right is yours (at a left, gentle bend in the road, just before you see in the distance that the road is going to make a sharp bend to the right). Park, and now look for the small, brown Wonderland Trail sign near the end of where you parked, heading downhill into the forest.

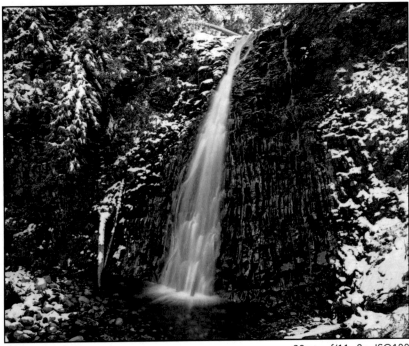

Martha Falls 20mm f/11 2s ISO100

Time	Best Good				
Budget	15-30 min	**Type**	Roadside	**Effort**	
RT Distance	<200 ft	**Δ Elev.**	~20 ft	**Zoom**	Normal

Reward

Effort

All of us notice the large boulders and substantial water flow of Stevens Creek as you drive over the bridge on the west end of Stevens Canyon, but I find that view to be too busy with debris. This unnamed, gentle cascade shown below is just to the left (west) of the big show. Take a look over the side of the road, and you'll see it.

An impromptu trail leads to it, but it does have some loose soil, rocks, and logs. As always, please hike within your means. Be safe.

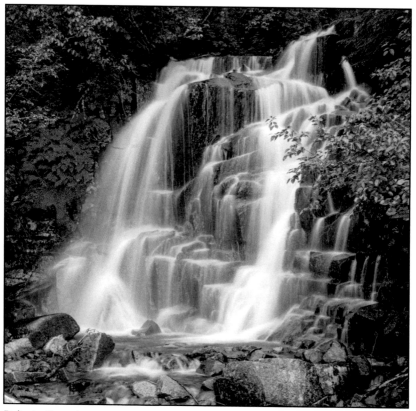

Delicate Cascade 35mm f/11 0.8s ISO400

Afternoon water flow is always greater, thanks to snow melt throughout the day. (In case you find yourself looking for this cascade during the morning, and find it underwhelming. Check back later in the day for better results.)

Time	Best	☀ ☀ ☀ ☀ ☀ ◑	Reward	✹ ✹ ✹ ✹	
Budget	30-45 min	Type	Roadside	Effort	🔋🔋🔋🔋🔋
RT Distance	<200 ft	Δ Elev.	<10 ft	Zoom	Wide Angle

I think these are always fun – to look at, and to photograph – and I usually seek-out places in national parks where the effect translates well within a photo.

This book is full of waterfall photos and daytime vistas... As such, in the Tips & Techniques section, we have plenty of general information on capturing those shots. But here, we have a pretty unique topic, so I'll lay-out an abundance of pointers specific to this activity.

But let's address the "where" question first. My rule of thumb is that you're composing for 3 key features at minimum here – a car's tail light "trails," the starry night sky, and then something interesting that captures "where you are." Obviously for the shot on the following page, I selected a tunnel – this happens to be the more westerly one on the Stevens Canyon Road, and I had set up on the west side of that tunnel.

This west tunnel has a nice, geometric stone arch at its entrances. There is another tunnel at Box Canyon – it has unique, rugged natural stone entrances.

An alternative location is Inspiration Point. This location is presented on Page 9, Map ii. Here, you can frame Mount Rainier, the night sky, and tail light trails as well.

OK, so now that we have a few location options at your disposal, let's tackle the technical how-to, from primary setup to final camera adjustments. (All photographers know the one truth about "rules" in photography are that they're meant to be broken, so please think of all the following as guidelines or starting points. Experimentation is encouraged!)

Assuming you are roadside (to your subject vehicle or vehicles), work in the direction that permits capturing the passing car's tail lights. Red tail lights are interesting, and the passing car's headlights will aid in your overall light capture by "painting" the roadway (and tunnel entrance) with light. The issue with headlights, is that if captured head-on from this vantage, the bright light will illuminate the inside of your lens and in essence totally wash-out your exposure.

Some sort of rigid camera support is mandatory. I recommend a tripod. A headlamp or flashlight also helps immensely.

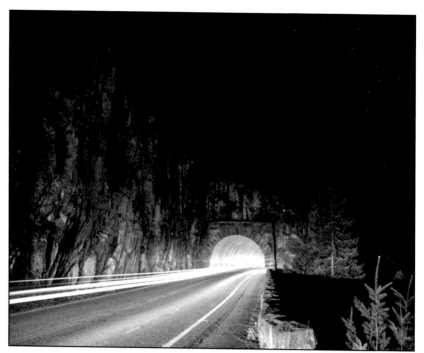

Eastbound on the Stevens Canyon Road 35mm f/2.8 15s ISO400

Lens selection... If you have the option, a fast wide angle is best. By "fast," I mean f/1.4-f/2.8. And by wide angle, 35mm or wider. You can use a slower lens, it just means there will be some compromises to ISO and shutter speed. And lenses with longer reach than 35mm will begin to struggle with depth of field and capturing the whole scene. This is all a bit subjective, so if you have multiple lens options, try each of them out, and learn their strengths and weaknesses for this work.

Here, perhaps, is the hardest part... You're going to need to manually focus your lens to infinity and leave it there. Leaving autofocus turned on is the best way to a very frustrating evening. It just won't work. So, illuminate something in the distance, lock-in focus, and leave it there. (Hopefully your lens has a focus window, and if it does check the lens' setting occasionally, to ensure it hasn't moved.) Warning!: If you are using a zoom lens for this, you cannot zoom in or out after you have set focus. Focus is only set for a particular focal length. So if you're using a zoom, be careful of this as well.

Alright, we're getting close... Compose your shot, as best you can. (This can be difficult sometimes, depending on how dark it is.) If after you take some shots, you can make some alignment and positioning adjustments.

Set your camera body to Manual mode, and now we need a starting point... The following table lists some options.

Aperture	f/1.4	f/1.8 or f/2	f/2.8	f/3.5 or f/4
ISO	100	200	400	800
Shutter Speed	15 sec	15 sec	15 sec	15 sec

You're ready to go. Now, using either a timer or a remote shutter release, listen for an approaching car, begin your exposure, and wait to see what happens! Take a look at your screen, and adjust accordingly.

Generally, you want to keep your ISO as low as possible, to minimize noise. Those of you with faster lenses (f/1.4 to f/2, for example), may find that you need to stop down to f/2.8 for depth of field (focus throughout your frame). Adjust the shutter speed (8 to 30 seconds) to suit your needs.

That's basically it. Be careful, good luck, and have fun!

Oh wait, there's more good news! This same technique works well for photographing the Milky Way. The very short summer nights at Mount Rainier National Park make capturing it a bit challenging, but if you're timing is right Sourdough Ridge (27) is a great place for a composition. The below was taken in early August at 10:30pm.

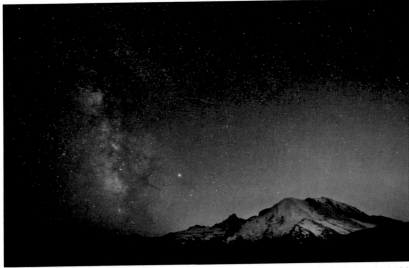

Mount Rainier and the Milky Way 14mm f/2.8 30s ISO1600

Time Good		Reward
Budget 30 min	Type Loop	Effort
RT Distance ~0.3 mi	Δ Elev. ~20 ft	Zoom Telephoto

Box Canyon is a wonderful example of a very pleasant stop for tourists, but a stop that doesn't really deliver for photographers. Its uniqueness makes it deserving of exploration, so if you do have 30 minutes (really any time of day will do), stop and take a break for a look.

Box Canyon

100mm f/16 1s ISO50

Some orientation will help here... All of the "action" is on the east side of the tunnel. Please drive slowly – a lot of people are walking and exploring here. You will be doing the same. Park in the main lot, east of the tunnel and bridge, on the south side of the road. Adjacent to the parking area, also on the south side of the road, are some geology and history information boards. OK to skip this, if you are short on time. There is nothing to photograph here. The short trail to the box canyon viewpoint is across the street. (Follow the pedestrian path to cross the road.)

It's a short loop, and you can travel light – my recommendation is to carry your tripod, at least a telephoto zoom, and any filters that you might like to employ.

Your prime destination is a foot bridge that crosses the canyon at the north end of the loop. This site provides the best view down into the canyon, and where your tripod and any filters might come into use.

Lighting can be very weird here, to say the least, so if you have a kit of graduated neutral density filters, they may help a lot.

Continuing your hike now away from the foot bridge, you'll return to the road. I have explored further south and west on the Wonderland Trail here, but didn't find anything worth pursuing. Therefore, I would complete this trip by walking along the south side of the car bridge and checking out the views there. On a clear day, Mount Adams is visible in the distance. And bonus – some Swallows have nested in the stone structure of the bridge, so you'll likely see them around.

Violet-Green Swallow 300mm f/5.6 1/160s ISO100

Ohanapecosh

Backbone Ridge to Deer Creek

Vine Maple at Ohanapecosh Campground 135mm f/8 1/80s ISO400

Time Best Good		Reward ✸ ✸ ✸ ✸
Budget 1-1.5 hr	Type Lollipop Loop	Effort 👢 👢 👢 **👢 👢**
RT Distance ~1.5 mi	Δ Elev. ~40 ft	Zoom Normal

Grove of the Patriarchs is a must do.

Seemingly "in hiding" on a small island is a grove of old growth Western Red Cedars, Douglas Firs, and Western Hemlocks. We hear about the old growth forests of centuries ago, but we rarely get to experience these trees' size. Well here is our chance. They exemplify majestic.

Any time of day will work as a tourist, but as a photographer you will have much greater success early in the morning or late in the afternoon. Once the sun is higher in the horizon, the lighting can become quite harsh among the big trees and the delicate Vine Maples much closer to the forest floor. (Overcast conditions work well too, anytime of day.)

Fall Color on the Ohanapecosh River 50mm f/5.6 1/13s ISO200

Some site-specific commentary on lenses: It's debatable if a wide angle zoom has much of a place among the trees here... I have used wide angles successfully with Coastal Redwoods and Sequoias, but the trees at the Grove of the Patriarchs seems to favor longer focal lengths. The wider angles really tend to "shrink" their presence and majesty. The same is true for telephoto focal lengths... Not many subjects for their use either. But, perhaps you have some tricks up your sleeve that I do not. If so, take 'em.

My Mom and Gigantic Trees

50mm f/2 1/60s ISO200

From the parking area, the trail heads north along the Ohanapecosh River. You'll get a nice sample of some larger trees along the way, but the real show is on the other side of the river on an island. You have to earn your entry onto this island, however, by crossing a rather bouncy (albeit safe) foot suspension bridge. (You'll see signage urging hikers to make the trip across the bridge only one at a time. Great advice, but if you're confident on your feet, and if you will match your partner's stride and step, it can be comfortably passable with multiple people as well.)

The tour through the trees on this small island is a loop. Follow whichever direction you please... It will not take long to complete the loop. In fact, my photography recommendation is first to make the loop as a casual observer. Take in the trees and their surroundings on your first pass. Some of the trees are 1,000 years old. They won't mind if you pass them twice. So, on your second pass, now that you've gotten to know them a bit, take out your camera and get to work.

Capturing their size can be challenging. If you're using a digital camera, and as you review some of your shots, you'll quickly see what I mean. Therefore, do take some pictures with people in view – this will help illustrate their size. (And candid shots of people nearly always present better than staged ones. So if you're traveling with others, here's a great chance for them to make a cameo in your landscape photo album.)

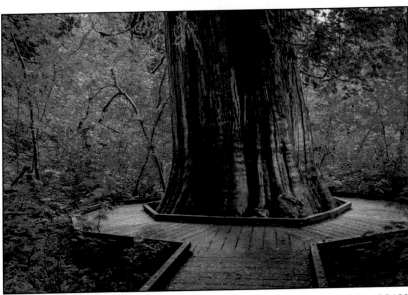

King of the Patriarchs 35mm f/8 0.8s ISO100

A Tranquil Exit

28mm f/16 4s ISO200

Tip: If you are exploring this trail on a hot summer day, and especially with kids, the Ohanapecosh River has several very welcoming beaches along its edge for cooling your feet and feeling the chilly air, thanks to the passing water.

Time Best Good		Reward
Budget 45-60 min	**Type** Out & Back	**Effort**
RT Distance ~0.6 mi	**Δ Elev.** ~300 ft	**Zoom** Normal

Silver Falls is cool – and I mean that from a color temperature perspective. (A little photographer's humor.) Something magical happens with the water at the base of the falls and just downstream as it makes its way through a narrow chasm, underneath a bridge that you can walk over – it turns to a wonderfully mystical blue color.

There is a real cluster of trails in this area that serves the falls. My preference is the one that is the shortest, because it makes the most of your time, but it is also the most steep. If the steepness is a deterrent for you, check out the Ohanapecosh Trail map; there are other, longer routes from various starting locations.

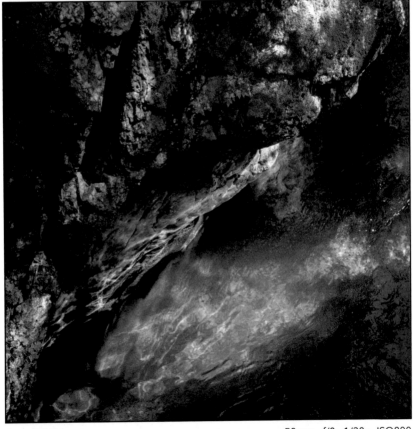

Beautiful Blue 50mm f/8 1/30s ISO800

From the Stevens Canyon Entrance "fork," go south on Hwy 123 towards Ohanapecosh. But be ready to pull off – the small parking area comes up quickly, at only about 1/4 mile down the road. Park, and you will see a trailhead sign. The trail descends somewhat steeply, with one switchback, before ending at the falls.

Enjoy photographing the falls and the colorful pools and rocks from multiple viewpoints (including the "formal" viewpoint just west of the bridge), and once finished head back up the trail!

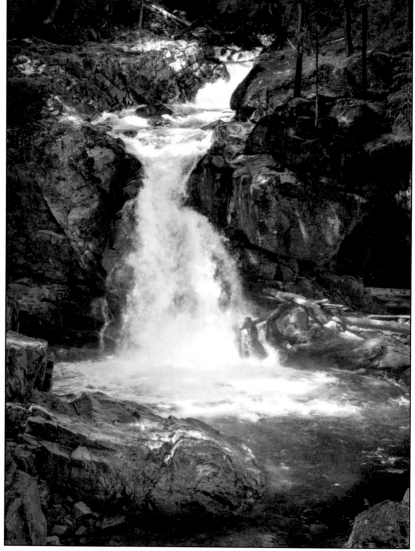

Silver Falls

70mm f/11 1/100s ISO800

Time Best Good		Reward			
Budget	30-45 min	Type	Loop	Effort	
RT Distance	~0.4 mi	Δ Elev.	~20 ft	Zoom	Norm, Tele

My family and I love to camp, and for families Ohanapecosh delivers. The Ohanapecosh River meanders right through the middle of the campground and offers a wonderful swimming hole to revitalize the body. (Without any showers in this national park, here is your chance to refresh!)

For casual visitors and photographers, it offers a spacious and very informative Visitor Center, as well as a short but delightful hike through dense vegetation and some very curious hot springs. Though, do not expect the magical hot springs like those at Mammoth in Yellowstone National Park, but rather some much smaller in comparison, but still fun to experience.

And a perk – telling others about your visit to "Ohanapecosh" just sings of Native American heritage and positive interest. So, make the bend south on Highway 123 and check it out!

The Hot Springs loop has numerous entries and exits, but the most typical one is behind the Visitor Center. Alike hiking Trail of the Shadows (2), I recommend to hike it counterclockwise, so again you can follow the flow of the hot springs water downhill.

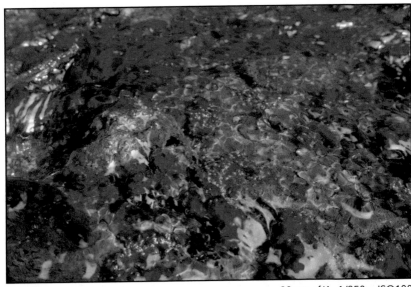

Hot Springs Water 28mm f/4 1/250s ISO100

Occasionally bend down for a good look at the life and texture within the water. For those of you interested in closeup / macro photography, this is a good place to visit. (And a superb walk for casual education with kids.)

Delicate Tall Grass Comforts Decaying Tree 300mm f/5.6 1/160s ISO200

Here is a phenomenon that seems constant throughout the forests of Mount Rainier National Park – a Western Red Cedar growing along-side a Douglas Fir. It seems they have grown alongside each other for most of their lives, as their sizes are usually similar. And they're so close, there's no doubt their roots would be dramatically intertwined if we could peer underground.

But why?

Having conducted some research, the best explanation that I have come across (though not pertaining exactly to these two species) has to do with either bacteria or fungus in the soil. These trees may be helping one another cope with these subsurface life forms.

Or perhaps not. I'm no botanist. At any rate, I wish that I knew exactly why it is. If you know, please write!

Now that you're on the lookout, it won't take long to see these pairs seemingly everywhere.

Partners in the forest.

Doug Fir and Western Red 28mm f/2 1/30s ISO100

Cayuse Pass

Deer Creek to White River NP Entrance

White River Valley Viewpoint 70mm f/11 1/100s ISO800

Time	Best Good								Reward	🏵 🏵 🏵 🏵
Budget	45-60 min		**Type**	Out & Back		**Effort**	👢👢👢👢👢			
RT Distance	~0.5 mi		**Δ Elev.**	~10 ft		**Zoom**	Normal			

Much of what was said about Reflection Lakes (13) holds true for Tipsoo Lake... One of the Mount Rainier "quintessential" compositions. Best at sunrise for prime color and calm water.

So now let's focus on the differences. There are 3 noteworthy ones...

First, as you can see, Mount Rainier appears a lot further away. It is. There's really no hiding this – even with a telephoto. So while it's not in your face as much with Reflection Lakes, its smaller size (or scale) allows for us to fill the frame with other interesting subjects – namely foreground and an encompassing view of the trees surrounding the lake.

Second, you have two distinctively-different elevations from which to shoot from for Tipsoo Lake. The traditional lakeside view – which I think is especially wonderful when wildflowers are in bloom – and one from the road above, as it makes its way up the hill to Chinook Pass. So my advice is this – let the wildflowers choose for you. If they're out, work lakeside. If they're not, try from above.

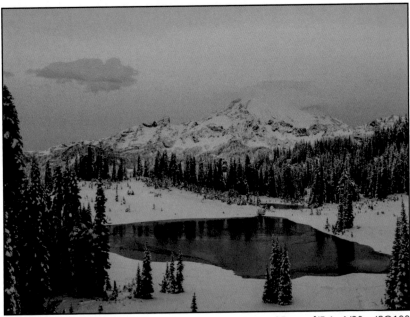

Tipsoo Lake from Highway 410 35mm f/5.6 1/30s ISO100

Finally, if you're coming in from the north (such as from Enumclaw, etc), and racing against the clock for a picturesque sunrise shot, this is a sensational vantage and getting to it is relatively easily. (Reflection Lakes is an additional 45 minutes away!)

So you may take your pick – either park at the formal parking lot and hike an easy 1/4 mile to the far side of the lake (clockwise is the most direct route), or park curbside up on Highway 410 and set your tripod up very close to your car. Both are marvelous.

And that's basically it. The rest is quite obvious. 'May the sky and colors be in your favor!

Advanced Photography with a Pinch of Luck: This can be a sunset shot, when the setting sun is barely poking through the trees. You'll have to stop-down to f/16 or smaller, to create that "sunstar" look, and in all likelihood you'll also need to employ a graduated neutral density filter (a "reverse" ND filter is best) for likeable results.

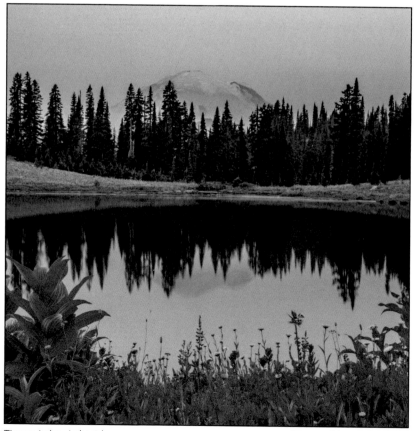

Tipsoo Lake - Lakeside
50mm f/22 2s ISO100

Time	Best Good	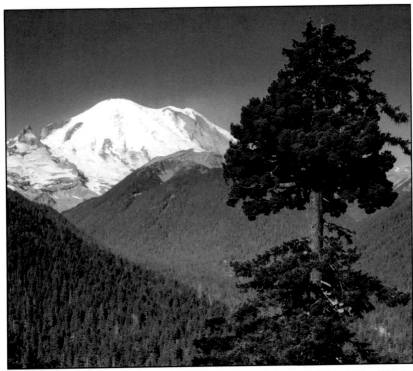 ☀ ☀ ☀ ☀ ◐	Reward	✹ ✹ ✹ ✹	
Budget	15 min	Type	Roadside	Effort	
RT Distance	<200 ft	Δ Elev.	<10 ft	Zoom	Norm, Tele

This one's so easy, it warrants a stop – no matter what time of day. And if you're entering the park from the north, this is your first, best view of Mount Rainier.

This vista affords a handful of options, from broad valley-encompassing shots with the White River in view, to telephoto compositions of Mount Rainier's alpine peak. Take a look – the photo on the inside cover is from this vantage, at first light, along while the moon was quickly setting. It's a marvelous vista.

There are actually two pullouts here. The unobstructed and more popular one is 0.3 mile south of the turnoff to the White River Entrance. A second pullout is 1.1 mile south of this same junction, and offers more "trees in the foreground" options. Both are great, but if I were to recommend one, it would be the more northerly stop.

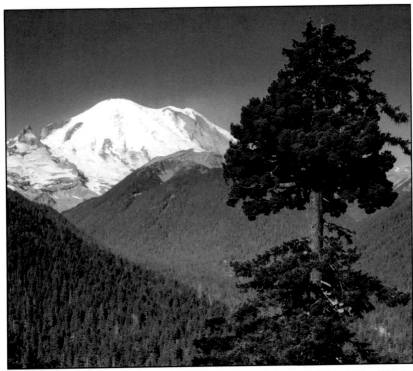

Valley Vista　　　　　　　　　　　　　50mm f/16 1/15s ISO100

Sunrise

White River NP Entrance to Sunrise

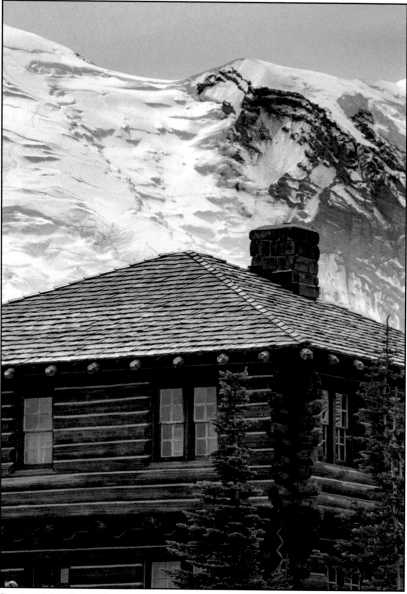

Sunrise Visitor Center Annex 200mm f/16 1/100s ISO100

Time	Best Good									Reward				

Budget	15 min	Type	Roadside	Effort

RT Distance	<300 ft	Δ Elev.	<10 ft	Zoom	Normal

If you're on your way to Sunrise – literally, as you're reading this right now – and you've long ago turned off of Highway 410, you're probably finding yourself somewhat amazed at just how long this drive is to the top! So, unless you're really hustling to beat the rising sun, I recommend cooling off a moment and taking a short break at this final hairpin turn, known as Sunrise Point.

The vista is 360°. Hello Cascades! *Consider a panorama shot here.*

Cascades to the Northeast 28mm f/5.6 1/800s ISO100

The stop is also at the trailhead for the **Palisades Lake Trail**. Seven lakes are served by the 3.6-mile, one-way trail. (Round trip, the hike is 7.2 miles.) Route information is available at the trailhead sign. The most photogenic lakes are Hidden Lake and Upper Palisades Lake, so to see the best of the hike you'll have to go all the way to the end. No views of Mount Rainier exist along the route, which makes it a viable option for those heavily-clouded days where the mountain is not even visible from the Sunrise Visitor Center area.

Wildflower aficionados rejoice! This national park can really deliver. The only "gotcha" is that the wildflower season is very short-lived. Summers here are already short, and wildflowers – depending on the location within the park – may only be around for 2-3 weeks.

Though, I think by now you already know this. It is, after all, why many people seek out this destination for summer visitation. So what can you do, as a photographer, to maximize your yield while here? Get creative with your technique!

Shoot wide, and then frame-in close. Make time to changes lenses.

Experiment with depth of field. Set your aperture wide. But also stop down (f/11 and smaller)... Don't get hung-up on the technical bits of diffraction and the limitations of your camera. The beauty and texture of the flowers will hide this nuance.

Shoot from up high. And also get down low. Seek out patterns. Try off-angle perspectives. Nature is not always on level.

The point is – take home as much variety in compositions as you can. What may seem elegant in the moment may disappoint a bit later. It could be those curious shots that you cherish most.

Hillside or Off Angle?　　　　　　　　135mm f/11 1/125s ISO400

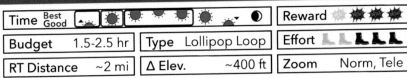

Time	Best Good		Reward	
Budget	1.5-2.5 hr	**Type** Lollipop Loop	**Effort**	
RT Distance ~2 mi		**Δ Elev.** ~400 ft	**Zoom** Norm, Tele	

For those wanting to experience the best "nearby" view Sunrise has to offer and are willing to get their legs and lungs revved-up a bit, this is the hike. I like this vista because you can frame the Visitor Center below the mountain, and the buildings look miniature in comparison!

The formal "Sourdough Ridge Trail" also serves as a taxiway of sorts, if your desire is to climb higher and further out to some adjacent peaks. But – for this narrative, my aim is to keep things simple – for you to experience the quintessential Sourdough Ridge views, and then head back down to the Sunrise base area for use of your time elsewhere. (The "published" Sourdough Ridge Trail is a loop west to Frozen Lake and then back towards Sunrise. Unfortunately though, once you've left the ridge area just above the main area, from a sightseeing perspective, you'd be wondering why you put in the time. It's a bit desolate, and not a lot to see or photograph.)

I'm going to break stride here a bit, and provide some aerial views for these trails around Sunrise... The printouts that you can obtain online or at the Visitor Center aren't to a scale that emphasizes the details well enough to be useful right around this main area. The following is the hike I recommend for you to take:

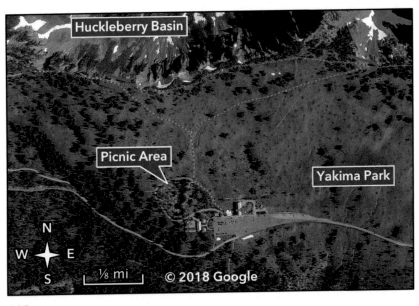

This is one of the ever-popular wildflower meadows at Mount Rainier National Park. It's really at its best when they're blooming, but the season is brief, usually in late July. Watch the wildflower reports on the Mount Rainier National Park website.

The Sunrise area has a rather large maze of picnic tables nestled amongst trees behind the Visitor Center and restrooms... Consider having your own lunch either before or after hiking this trail. It will be as memorable as the hike and views itself!

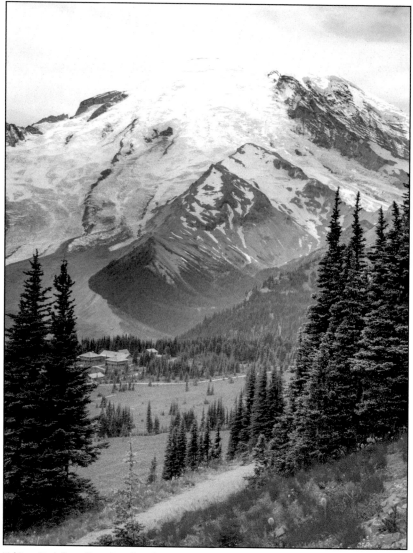

Yakima Park from Sourdough Ridge 50mm f/11 1/125s ISO100

Time Best Good		Reward		
Budget	3-4 hr	Type	Out & Back	Effort
RT Distance ~5.6 mi	Δ Elev.	~900 ft	Zoom	Norm, Tele

Pack your lunch (or your breakfast!) and head out for the Mount Fremont Lookout for a sensational view of Mount Rainier with Berkeley Park in the foreground.

Where the hike to the Tolmie Peak (34) lookout provides Eunice Lake photography options, Mount Rainier feels a bit distant. Here, at Mount Fremont, Mount Rainier is soooo close!

The route is well-marked and on many, if not all, the Sunrise area maps. Follow the trail towards Sourdough Ridge (27), and once at the "Y" head left (westerly). This is the route to Frozen Lake.

Despite its interesting name, Frozen Lake is mostly uninteresting. After skirting its barrier arrive at an intersection of several trails. Follow signage to the right for the Mount Fremont Lookout.

Continue upward, though the grade is never extreme. Approach a "false summit" at about 2.2 miles... You still have a half of a mile to go, though the elevation gain to the end is minimal.

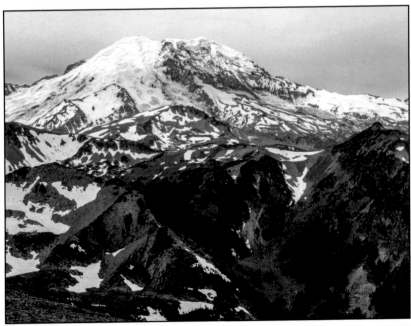

Mount Rainier and Berkeley Park 35mm f/11 1/320s ISO200

At an elevation of 7,181' the Mount Fremont lookout is the highest tower that remains in the park. Walk up its stairs and look inside. It is still occasionally used.

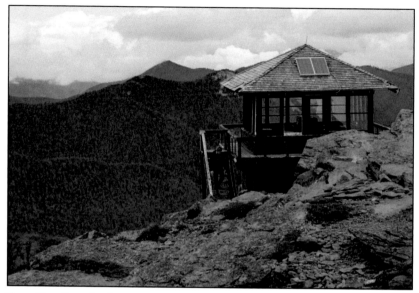

Tower Tour Complete! 150mm f/5.6 1/500s ISO100

Regarding time (of day) to visit... Sunrise and sunset can be spectacular here, but this is a decent hike to do in the dark. Also, some real luck is involved for the right sky conditions (not to mention temperature and wind). So, it's a bit of a gamble, but the payoff could be grand. Afternoon, especially late afternoon, should be avoided due to the southwesterly direction of viewing Mount Rainier. I prefer early to late morning, with a lunch break at the top.

Bring your telephoto if interested in wildlife. Mountain goats frequent the valleys below. I have photos of some, albeit distant. This Chipmunk, on the other hand, wanted to sample my mountaintop cuisine. I denied him the opportunity.

100mm f/4 1/640s ISO200

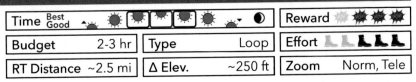

Time	Best Good								Reward				
Budget	2-3 hr	Type	Loop	Effort									
RT Distance	~2.5 mi	Δ Elev.	~250 ft	Zoom	Norm, Tele								

I'm a fan of "loop" hikes. I seek them out. I mean, why retrace your steps, if instead your entire hike can be something new?

Of the four Sunrise area hikes in this book, this one is best for escaping the heavy summer crowds.

Shadow Lake is sort of a hidden lake west of the Sunrise base area. It is not the turquoise body of water that you see in the distance from the Emmons Vista. Like most hikes in this area, it is at its prime when the wildflowers are blooming. You'll get twice as much (or more) out of the experience if your visit's timing matches their presence.

This is also the kind of hike that checks several boxes... You begin with a very pleasant, short section of the hike away from the base area through a forest on a narrow trail. Eventually, you find yourself out in more open air, and after a quick zigzag continue west along a very beautiful open space with a stream meandering about. Bearing left (thanks to good signage) at your first major fork, you are now on a section of the Wonderland Trail, eventually coming into the Sunrise Wilderness Camp. (A very curious outhouse is adjacent to the trail. I recommend a fun picture, and recommend against opening the

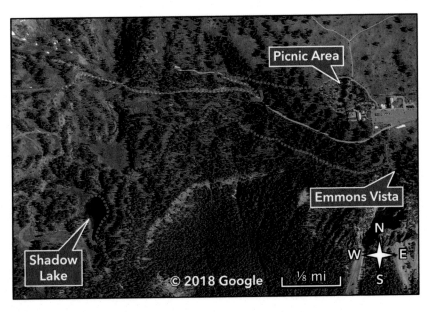

Jeffrey's Shooting Star

300mm f/5.6 1/200s ISO400

door!) Immediately after the camp area, turn left and make your approach to Shadow Lake.

If conditions permit, you are able to loop the lake clockwise. There is a peekaboo view of Mount Rainier. The only real trick here is to find some interesting foreground elements to include in your photo. In mine below, I used a polarizing filter to eliminate enough reflection so that the surface textures at the lake's bottom may be seen.

Resume your hike, and now work your way east back towards the base area. The remainder of the hike mostly weaves in and out of tree cover, but again – if wildflowers are blooming, there are typically many patches of them back on the way up.

You'll know you're getting close when the density of visitors picks back up. And it will.

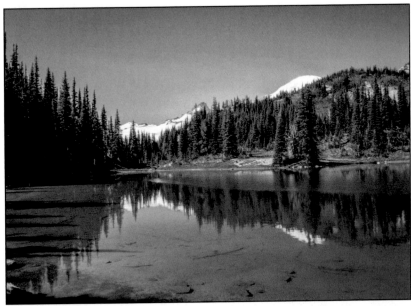

Shadow Lake 28mm f/22 1/6s ISO100

If you're willing to break stride one final time as you approach the Sunrise base area, and you will not be doing the Silver Forest Trail, the Emmons Vista (viewpoint) is worth a small detour. The junction from the trail you're on to the viewpoint is obvious, and in all likelihood you'll notice people heading in its direction – it's the easiest-to-access noteworthy viewpoint near the base area, hence the abundance of foot traffic en route to it. I recommend it; however, personally I'm like a horse to water near the end of a hike, and too often I find myself unwilling to explore any further. (Humor.)

Time	Best Good									Reward				
Budget	1 hr	**Type**	Out & Back	**Effort**										
RT Distance	~1 mi	**Δ Elev.**	~150 ft	**Zoom**	Norm, Tele									

The Silver Forest Trail is a simple, little hike – with the least elevation loss and gain in the Paradise area. Its most impressive vista is near the beginning – the Emmons Vista Overlook. Beyond the overlook, the trail meanders east, along a slope and through a "silver forest" of lifeless, but interesting, trees.

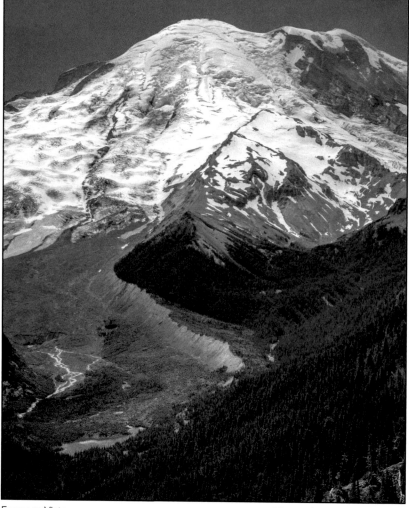

Emmons Vista

50mm f/8 1/200s ISO200

These trees are scattered about, so do not expect this to be like a walk through a dead Sherwood Forest. And honestly, their beauty isn't singularly magnificent, but rather their juxtaposition adjacent to the verdant subalpine ecosystem is what makes them striking. The contrast they provide photographers is great.

Circle of Life 135mm f/8 1/200s ISO800

The hike is advertised as 0.8 mile in length (one-way) from the parking lot. Truthfully, the best of it is during the first half. My recommendation is to hike this one based on time, and not mileage. Thirty minutes out, and 30 minutes back will net you approximately a 1-mile round trip, and I think you'll have experienced the best.

Carbon River

Carbon River NP Entrance

On the Shore of the Carbon River 135mm f/5.6 1/320s ISO100

Time	Best Good							Reward	✳ ✵ ✵ ✵

Budget	30-45 min	Type	Loop	Effort

RT Distance	~0.3 mi	Δ Elev.	~10 ft	Zoom	Normal

I believe the most sensational rain forest in Washington state (and perhaps all of the contiguous United States) is the Hoh – located in Olympic National Park. If you have ever visited it, you know exactly what I mean. Here, we have a "mini" Hoh, of sorts – an inland, temperate rain forest, on the northwest corner of Mount Rainier National Park.

The loop is short – in fact, it's more of a walk than a hike. The trail is well-marked and immediately adjacent to the Carbon River Entrance parking lot. My preference, in part because it is so short, is to walk it in one direction, and then walk it again the opposite direction. This

Cloaked in Moss　　　　　　　　　　35mm f/5.6 1/8s ISO800

way, you can seek compositions as you walk at your left, right, and in front of you, without continuously having to look back over your shoulder to see if you've missed something.

One Happy Mushroom 20mm f/22 4s ISO200

Lighting is best early and late in the day, but if you really want the ultimate experience, seek-out an overcast or rainy day – in which case, any time of day will do. This is when the colors are at their most vivid.

Time	Best Good		Reward	✸ ✸ ✸ ✸
Budget	4-5 hr	Type	Out & Back	Effort ⫞⫞⫞⫞⫞
RT Distance	~10 mi	Δ Elev.	~1,100 ft	Zoom — Wide Angle

Before I might discourage some with mileage challenges (albeit with a solution!), let me say that this hike and its two destinations are **worth the effort**.

As I see it, accessing the hiking-only trailhead is an effort in and of

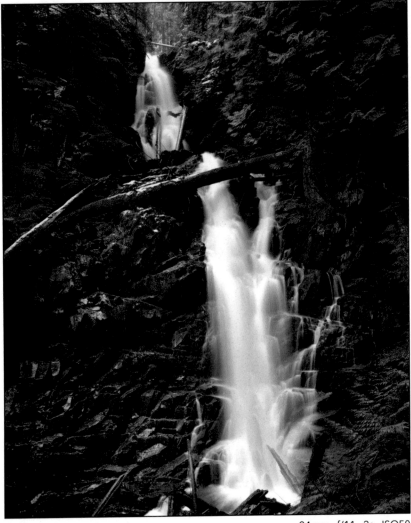

Ranger Falls 24mm f/11 2s ISO50

itself. From the parking area it's 3.2 miles along a once-not-long-ago-open-to-vehicles gravel road before you even reach the trailhead for Ranger Falls and Green Lake. It is through a very pretty forest, but hiking along a gravel road isn't the most alluring endeavor.

Solution: Bicycle the road, and hike the trail. Truthfully, few do this, but I think it yields a sensational bang-for-the-buck. Hereby known as a Bike 'n Hike! Otherwise, it's simply a Hike 'n Hike. (You get the drift.) From the parking lot, along those 3.2 miles, you gain about 250 ft of elevation. (It's not that noticeable. But just enough that you notice it on the return!) Then, hiking from the trailhead to Green Lake, you gain another 800 ft, but only over 1.8 miles.

Now that we've cleared some logistical issues, let's talk Ranger Falls and Green Lake... The trail is truly bound at its ends by the access road and its final destination, Green Lake. And just over the halfway mark (1 mile) is a short turnoff to Ranger Falls, a lovely 3-drop waterfall of 170 feet total height. Continue up, and find ultimately find Green Lake with its ethereal, greenish glow. Be careful with your footing, as the soil around the logs is usually wet. The peak in the distance is Tolmie Peak (34), covered in the Mowich Lake section.

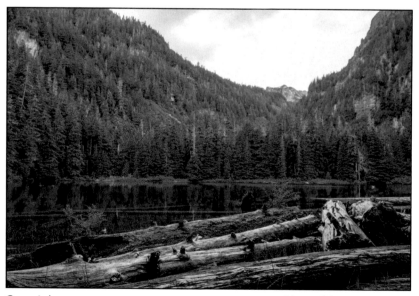

Green Lake

24mm f/8 1/60s ISO100

You'll fare the best having brought along a tripod, as the falls capture best under very slow shutter speed.

Make work, have an eat, and enjoy your descent back to the car!

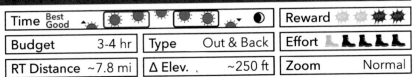

Time	Best Good	☀ ☀ ☀ ☀ ☀ ◑	Reward	✸ ✸ ✸ ✸	
Budget	3-4 hr	Type	Out & Back	Effort	👢 👢 👢 👢 👢
RT Distance ~7.8 mi	Δ Elev.	~250 ft	Zoom	Normal	

Where the hike to Green Lake combines distance and elevation, Chenuis Falls is really a distance-only affair. Yes, there's some elevation gain, but it's so minimal that it's almost indistinguishable.

For continuity, the duration is advertised as hiking-only, but as described on the Green Lake hike, if you opt for a Bike 'n Hike, the effort and duration would change radically. I did this one with our 7 and 10 year-old daughters one summer day via the Bike 'n Hike method, and we had a blast. It took us 2 hours, instead of 4.

One half mile further east down the road than the Green Lake trailhead lies a hitching post and this trailhead. On foot, cross the Carbon River via a log bridge, and meander over rocks and not far into the woods to find the serene Chenuis Falls.

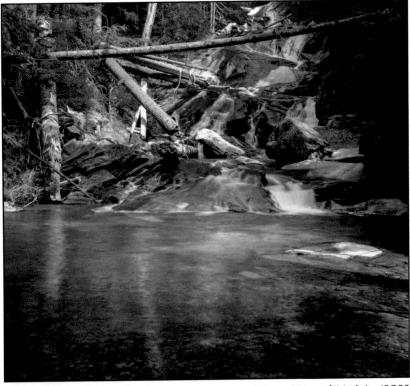

Chenuis Falls 35mm f/16 0.4s ISO50

Mowich Lake

Mowich Lake NP Entrance

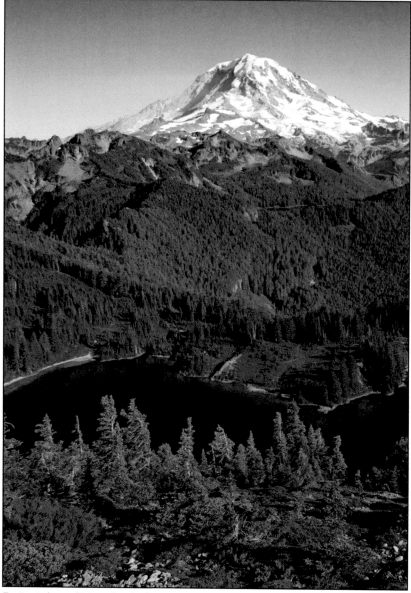

Eunice Lake and Mowich Lake from Tolmie Peak 16mm f/5.6 1/320s ISO100

Time	Best Good						Reward	🌸 🌸 🌸 🌸
Budget	3-4 hr		Type		Out & Back		Effort	👢 👢 👢 👢 👢
RT Distance	~6 mi		Δ Elev.		~1,100 ft		Zoom	Wide, Tele

If you have a burning desire to check off just one hike for *sure-fire* photos in Mount Rainier's northwest corner (including the Carbon River Entrance), this should be the one.

Now truthfully, it's not the very best hike, and it requires a heck of a drive to get to, but its photographic sites are top notch. Truly wonderful. And bonus if the wildflowers are blooming.

I don't mean to discourage with the "not the very best hike" part; I'm just trying to help set expectations of what you'll experience.

The journey begins at Mowich Lake. Since you're here for photography, my recommendation is to continue your drive past the main trailhead parking for Eunice Lake, and park closer to the end of the road – near the walk-in campground. This is a better place to take in the view of Mowich Lake. There is a boulder on the lake-side of this parking area that may be easily climbed. Get on up there, and enjoy the elevated vista it affords.

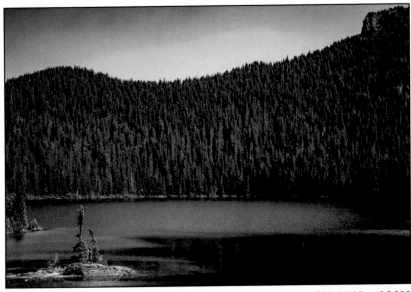

Mowich Lake 70mm f/8 1/125s ISO200

Your hiking trail parallels the lake's west shore, and continuing north on it ties-in with the trail towards Eunice Lake.

Now prepare yourself. Mentally, that is. This trail ascends a bit, and then seems to descend quite a bit, before finally ascending again more steeply closer to the lake. (Gaining elevation, and then losing it, just to have to gain it back can be frustrating. Well, maybe especially if you don't know it's coming. So, now you know.)

Your final approach to the lake will be obvious – the clearing in the trees ahead announces its presence. Then you see it – Eunice Lake. And then miraculously, your eyes catch your final destination – the fire lookout on Tolmie Peak. It's *waaaaay* up there. I cannot write what I heard another hiker say when she realized the climb still yet to come! It was a choice 4-letter word, and we all had a good laugh.

Eunice Lake is beautiful and typically very calm. People like to break here (either coming or going) for a swim. I'll leave that choice for you to make. I tried it once... the water is COLD.

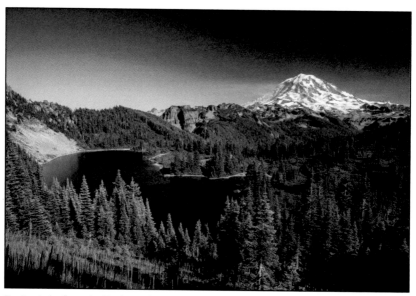

Eunice Lake from the Trail to Tolmie Peak 20mm f/16 1/30s ISO200

Onward and upward, Tolmie Peak is calling.

And finally, you see it – the historic fire lookout tower. Fellow hikers congregate, have an earned rest, enjoy the view, and inspect (from the outside only) this curious, old tower.

Midday is really best here, if you want maximum color in the waters of Eunice Lake below and Mowich Lake in the distance. I have to say, I also learned this the hard way. I tried for a very late afternoon / setting sun composition, and I was dealt very brown-looking water colors below.

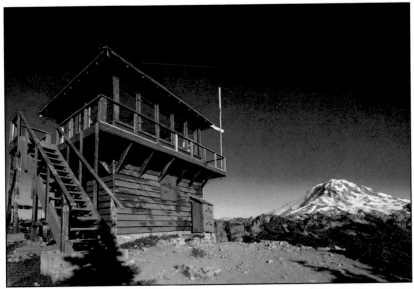

Tolmie Peak Fire Lookout 16mm f/11 1/125s ISO100

It's your turn to rest and enjoy the view. I recommend taking a little extra time here. It's enjoyable to see many groups of elated hikers reach their destination and witness also what you've now found so beautiful.

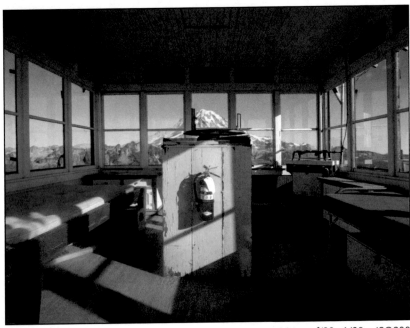

A Peek Inside 16mm f/22 1/80s ISO200

Time	Best Good	☀	Reward	🌟 🌟 🌟 🌟	
Budget	4-5.5 hr	Type	Out & Back	Effort	🥾🥾🥾🥾🥾
RT Distance	~6 mi	Δ Elev.	~1,300 ft	Zoom	Wide, Tele

Admittedly, I struggled with which of the two Mowich Lake area hikes to promote – Tolmie Peak or Spray Park? Once I realized why the choice was difficult, it no longer was a matter of choosing one, but rather how to present them.

Where Eunice Lake and the Tolmie Peak fire lookout are favorites for photographers, the hike to them leaves a bit to be desired. Enter Spray Falls and Spray Park. I'd say this hike's photographic subjects aren't as sure-fire, but the hike is knock-your-socks-off amazing. Perhaps the best in this book, if you're willing to put in the effort on its mileage and elevation.

The trailhead is adjacent to the walk-in campground, and the hike begins with a bit of a descent. The woods here are just fabulous, but don't stop too often for pictures – you have a long way to go yet.

At about 1.5 miles in, after some diverse terrain and a hike up a staircase (of sorts) you reach an intersection to the Eagle Cliff viewpoint. It's off to the right and spectacular when not socked-in by clouds. Check it out on the outbound journey and on the way back.

Right after this viewpoint is a small section of the forest with a real abundance of moss covering the trees. This area is worth a good look for interesting compositions.

Continuing on, soon you will reach another fork – this one is marked with a **very important sign**, but unfortunately it is extremely vague. One direction it points to the Eagles Roost campground, and the other direction to "water." I went the wrong way the first time. I assumed the campground was along the trail. It's not. **You want to go in the direction of the water!**

70mm f/3.5 1/50s ISO800

121

Midscript

Initially I intended for this 2-page section to be titled "Addendum," but then learned that an addendum is to be at the end of text. I wanted for it to be in the middle, hence "midscript." I hope this is appropriate!

In revising this book to the 3rd edition I have included some new sites and of course updated information throughout. It has haunted me a bit since its prior publications that I could not guide my readers to an adequate view of **Spray Falls**. It is possible, as seen here, and so an updated narrative is required.

Unlike other sites where I revised the original text, I have chosen to leave the original text for this site mostly unchanged. Why? Because I want to still make it clear that accessing a clear view of the falls may be unobtainable or unsafe for some people.

Hiking has risks — some routes more than others. So as always you must gauge the surroundings and your own ability to proceed safely. Please exercise good judgment on whether the routes described below are safe to pursue during your visit.

Option 1 - Crossing Spray Creek

The only practical means to cross the creek is over a fallen tree (or trees) that crosses from the trail side to the opposite side. I have now done this, as have others as you'll see tracks on the opposite side. The "quality" of the fallen tree (and its stability) can vary from visit to visit, as fast-moving water can change things. On my most recent visit there was a cluster of 3 trees that were very secure. I sat on the wood and scooted across on my bottom, using my hands. If you find a similar makeshift bridge, please do not chance walking across using your feet. Scoot on your bottom instead.

Once across you will find that many of the rocks along this hillside are loose. Prepare for a loose rock with every step.

Climb slightly for a good view of the falls. It is not necessary to get much closer, as the mist from the falls makes photography challenging. The photo at right is from this side.

Option 2 - Scrambling Closer on the Trail Side

It is possible to get an unobstructed view of the falls from the trail side, but you will need to scramble over rocks and through mud to achieve a higher vantage.

I have made my way along this side as well. Due to the mud (everwet from the falls' mist) and more loose rocks, I believe this is an even more challenging route than crossing the creek over a

steady log. The grade, in places, is steep, and it is slippery. Scurrying along on "all fours" (feet and hands) is required.

Either route, here is a hiking pro tip – always have with you a pair of leather gloves for hand protection. I carry a pair and use them more often than I ever would have imagined.

If you add photography of an unobstructed view of Spray Falls, figure on adding an additional 45-60 minutes to the hike's duration.

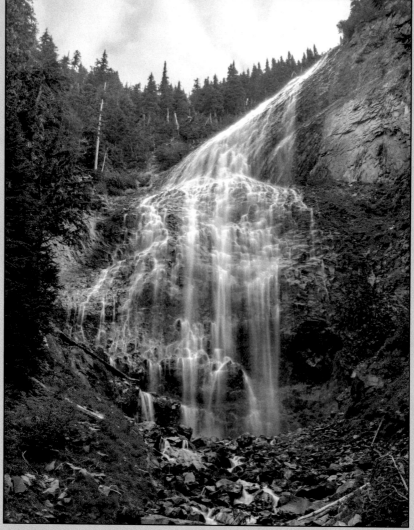

Spray Falls 40mm f/11 1/4s ISO100

Please be most careful if you elect to pursue any of these routes.

And not much further is a guaranteed, lovely shot – a log bridge crossing a pristine creek, with cascading water around and over an abundance of rocks and moss. (I really enjoyed this site – I hope you do too. This was my first stop to deploy the tripod and have some long-exposure fun.)

Mossy Cascade 16mm f/11 2s ISO100

Back on the trail with gear stowed, you quickly come to another fork, with signage directing you to Spray Falls. Take it, of course!

Bending around and hiking along a curious hillside of rocks, you approach Spray Creek. And here is where I hope that your luck is better than mine – I have not been able to find safe passage over the creek to the other side. Accessing the other side is the best means to

photographing the very high waterfall. So, please – be safe. Make a choice that is within your means. No waterfall is worth injury or death. These waters can move very briskly, and downhill so fast that one slip could be fatal. ...My point is, enjoy the scene (even without a photo, it's glorious), and photograph only as much as it is safe to.

Spray Falls Peekaboo 100mm f/8 1/40s ISO200

Alright, and now you have probably figured that the source of that waterfall is up at Spray Park – your next destination. Back to hiking!

Return and climb, finally to the forest's exit. It will be obvious – there is a log bridge to cross, and beyond is abundant light and a meadow.

Here, also, is where there seems to be great inconsistency among maps and resources on what exactly constitutes the boundaries of Spray Park and even more so the "end" of this hike. My advice is this (and a compass will help immensely)...

The log bridge I mentioned (just above) crosses Grant Creek. (Take notice of a very narrow trail almost immediately after you enter the meadow. We will explore this on the way back.) The main trail zigs and zags a bit, but mostly is heading due east. After about 600 ft (~1/8 mile) it curves left and begins more northerly.

After another ~1/8 mile it bends somewhat sharply to the right, heading east again. (Around this bend you may notice another very narrow trail.) As you head east now, only about 300 ft, you will see yet another very narrow trail to your right. Here is where our outbound journey ends, unless you are compelled to explore this subalpine meadow further. (If you were to continue on the trail, the next area to explore is Seattle Park.)

Taking that final narrow trail I mentioned leads you south to a tarn, with a boulder on its north side, perfect for stopping and setting up for a reflection of Mount Rainier in its shallow water.

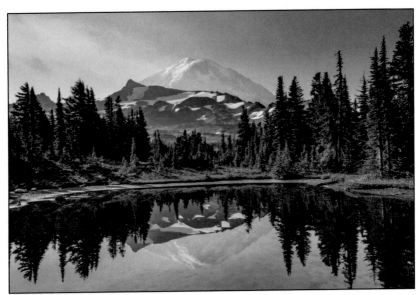

Tarn in Spray Park 28mm f/11 1/200s ISO100

You'll see that the trail continues west of the tarn. This leads back to that right bend mentioned earlier. Now take a left, and you're heading south, and back on the trail you initially hiked in on.

Back south (and then back west) in the direction of the log bridge, now it's time to take that narrow trail (now at your left) into an open meadow. This, I believe, is the essence of the Spray Park area. The trail continues towards Spray Creek, the water that feeds Spray Falls.

Explore as much as your interest and time (and your legs) allow, then finally begin back towards the trails that brought you here. Find your stride, and enjoy the descent.

Fireweed near Lee Creek 70mm f/5.6 1/80s ISO800

No.	Page	Site	Time	
			Best	Good
1	40	Kautz Creek Viewpoint	SS	-AM thru PM+
2	41	Trail of the Shadows	-AM & PM+	AM+ & -PM
3	44	Longmire District	-AM thru AM+ & SS	MID thru PM+
4	46	Carter Falls	-PM thru PM+	-AM
5	49	Comet Falls	-AM	AM+ & PM+
6	52	Christine Falls	-AM & PM+	-
7	56	Narada Falls	-AM	AM+ thru PM+
8	58	Skyline Trail	SR thru -AM	AM+ thru MID
9	62	Myrtle Falls	AM+	-AM & MID
10	64	Other Paradise Trail Options...		
11	66	Paradise Inn	SR	-AM thru AM+
12	67	Ruby Falls	-PM thru PM+	MID
13	68	Reflection Lakes	SR	-AM
14	70	Pinnacle Peak	SR thru -AM	AM+ thru MID & SS
15	72	Louise Lake	-	-AM thru PM+
16	74	The Bench	AM+ thru -PM	-AM
17	78	Martha Falls	-AM	-PM thru PM+
18	79	Cascade at Stevens Creek	PM+	-PM
19	80	Nighttime Car Light Trails	Nighttime	-
20	83	Box Canyon	-	-AM thru PM+
21	86	Grove of the Patriarchs	-AM & PM+	AM+ & -PM
22	90	Silver Falls	-AM & PM+	-PM
23	92	Ohanapecosh Hot Springs	-AM & PM+	AM+ thru -PM
24	96	Tipsoo Lake	SR	-AM & SS
25	98	White River Valley Viewpoints	SR	-AM thru SS
26	100	Sunrise Point	SR	-AM thru SS
27	102	Sourdough Ridge	-AM	SR & AM+ thru -PM
28	104	Mount Fremont Lookout	-AM thru AM+	SR & SS
29	106	Shadow Lake	MID	AM+ & -PM
30	109	Silver Forest Trail	-AM	SR & AM+ thru -PM
31	112	Rain Forest Loop	-AM & PM+	AM+ & -PM
32	114	Ranger Falls & Green Lake	-AM thru MID	-PM thru PM+
33	116	Chenuis Falls	-AM thru AM+	-PM thru PM+
34	118	Eunice Lake & Tolmie Peak	AM+ thru -PM	-AM & PM+
35	121	Spray Falls & Spray Park	-AM thru AM+	MID thru -PM

Reward (Wow's)	Budget	Type	Effort (Boots)	RT Distance	Δ Elevation	Zoom
1	15 min	Out & Back	0	~500 ft	~10 ft	Telephoto
3	45-60 min	Loop	2	~0.7 mi	~20 ft	Wide Angle
3	45-60 min	Meandering	0	<0.5 mi	<60 ft	Normal
3	1.5-2.5 hr	Out & Back	3	~2.2 mi	~500 ft	Norm, Tele
4	3-5 hr	Out & Back	4	~3.8 mi	~900 ft	Wide, Tele
4	45 min	Roadside	1	<500 ft	~20 ft	Normal
3	45-60 min	Out & Back	2	~0.5 mi	150-200 ft	Normal
4	4-6 hr	Loop	5	~5.5 mi	~1,700 ft	Wide, Tele
4	1-1.5 hr	Out & Back	2	~1 mi	~160 ft	Normal
(Varies)						
3	30 min	Roadside	0	<200 ft	<10 ft	Norm, Tele
2	30-45 min	Roadside	1	<200 ft	~20 ft	Norm, Tele
4	45-60 min	Out & Back	1	<0.2 mi	<40 ft	Normal
4	2.5-3.5 hr	Out & Back	4	~3 mi	~1,200 ft	Norm, Tele
2	30-45 min	Out & Back	2	<0.2 mi	~90 ft	Wide Angle
4	2-3 hr	Out & Back	3	~2.5 mi	~700 ft	Norm, Tele
2	1-2 hr	Out & Back	2	~1.1 mi	~500 ft	Wide Angle
2	15-30 min	Roadside	2	<200 ft	~20 ft	Normal
3	30-45 min	Roadside	0	<200 ft	<10 ft	Wide Angle
1	30 min	Loop	1	~0.3 mi	~20 ft	Telephoto
4	1-1.5 hr	Lollipop Loop	2	~1.5 mi	~40 ft	Normal
3	45-60 min	Out & Back	2	~0.6 mi	~300 ft	Normal
1	30-45 min	Loop	1	~0.4 mi	~20 ft	Norm, Tele
4	45-60 min	Out & Back	1	~0.5 mi	~10 ft	Normal
2	15 min	Roadside	0	<200 ft	<10 ft	Norm, Tele
1	15 min	Roadside	0	<300 ft	<10 ft	Normal
3	1.5-2.5 hr	Lollipop Loop	3	~2 mi	~400 ft	Norm, Tele
4	3-4 hr	Out & Back	4	~5.6 mi	~900 ft	Norm, Tele
3	2-3 hr	Loop	3	~2.5 mi	~250 ft	Norm, Tele
2	1 hr	Out & Back	2	~1 mi	~150 ft	Norm, Tele
3	30-45 min	Loop	1	~0.3 mi	~10 ft	Normal
4	4-5 hr	Out & Back	5	~10 mi	~1,100 ft	Wide Angle
2	3-4 hr	Out & Back	4	~7.8 mi	~250 ft	Normal
4	3-4 hr	Out & Back	5	~6 mi	~1,100 ft	Wide, Tele
4	4-5.5 hr	Out & Back	5	~6 mi	~1,300 ft	Wide, Tele

About the Author

Anthony Jones, who friends and family call "AJ," lives in the Seattle, Washington area with his wife and their two daughters.

In April 2011 he visited Joshua Tree National Park, laying the foundation for what would become regular photography pilgrimages to many other U.S. National Parks.

AJ enjoys the planning and logistics aspect of a trip as much as the trip itself, and in so he realized a shortage of available books focused on the photographer's specific needs while visiting national parks. Thus, his idea to write a series of these types of books was born...

Made in the USA
Middletown, DE
14 February 2024

49782691R00073